IMAGES
of America

ALISO VIEJO

Not many individuals are fortunate enough to be present at the birth of a new community and participate in its planning, design, construction, and growth. Since the land once known as the Moulton Ranch became the new master-planned community Aliso Viejo, the author was blessed with that unique experience. This book is his contribution to Aliso Viejo and the celebration of its 10th anniversary as a city.

ON THE COVER: Lewis Feeno Moulton and his late partner's widow, Marie Eugenia Daguerre, ran a successful cattle business on their vast Moulton Ranch at the turn of the 20th century. The last remaining 6,600-acre portion of the ranch would later become the 34th city in Orange County and one of the fastest growing planned communities in the country. (Courtesy of the Saddleback Area Historical Society.)

IMAGES
of America

ALISO VIEJO

Bob Bunyan and the
Aliso Viejo Community Foundation

ARCADIA
PUBLISHING

Published by Arcadia Publishing
Charleston, South Carolina

Library of Congress Control Number: 2010936400

For all general information, please contact Arcadia Publishing:
Telephone 843-853-2070
Fax 843-853-0044
E-mail sales@arcadiapublishing.com
For customer service and orders:
Toll-Free 1-888-313-2665

Visit us on the Internet at www.arcadiapublishing.com

*This book is dedicated to the men and women who built
Aliso Viejo and to the residents of this unique city.*

CONTENTS

ACKNOWLEDGMENTS

The publication of this historical document about Aliso Viejo would not have been possible without the assistance of numerous individuals and organizations. My sincere appreciation is extended to all of these contributors for their time, effort, and memory of people, occurrences, and events in years past.

My thanks to Jacque Nunez for information on and photographs of the early years and the Juaneno Band of Mission Indians. Thanks to the City of Laguna Hills for providing photographs of the Moulton family and for their early history of Orange County curriculum guide. Thanks to Marian Norris and the Saddleback Area Historical Society and to Gwen Vermeulen at the O'Neill Museum for providing wonderful old photographs of various ranch owners, and to Bob Blankman at First American Title Insurance for additional photographs of the Moulton Ranch from their extensive archive.

Photographs provided by the Barnes family depicting life on the ranch provide rare glimpses of that special place just prior to development. Thanks to Abrecht Photography, Tom J. Carroll, and Aerial Eye Photography for allowing use of their aerial photographs of the ranch during its development phase, and to Parker Properties and Leisure Sports, Inc. for providing photographs and helpful information about the Summit and Renaissance ClubSport.

Special thanks to Marilyn Smith at the Aliso Viejo Community Association and Carmen Cave and Mark Pulone at the City of Aliso Viejo for access to their photograph archives, as well as to Ray De Leon for access to his city event photographs. Thanks to Wendy Harder at Soka University for photographs of the university and to Lisa Telles at the Transportation Corridor Agencies for providing historical photographs of the San Joaquin Hills Corridor and information on fossil discoveries.

Gaining information on the acquisition and planning of Aliso Viejo would not have been possible without the assistance of Van Stevens, Art Cook, and Steve Delson from Mission Viejo Company. My special thanks to the Aliso Viejo Community Foundation for their support of this effort and their continuing commitment to preserving the unique history of Aliso Viejo. Unless otherwise noted, all images appear courtesy of the Aliso Viejo Community Foundation.

INTRODUCTION

Aliso Viejo, Orange County's 34th city, represents the last piece of the once vast 22,000 acre Moulton Ranch in South Orange County. Today, the city is a thriving community of 46,000 people and a testament to the master plan originally conceived over 30 years ago.

Located three miles inland from the Pacific Ocean, Aliso Viejo was once an area of farming and livestock grazing. Before Europeans entered the area, various tribes of Native Americans inhabited the land, hunting, foraging, and fishing to obtain the necessities of life. Prior to its development into the city known today, Aliso Viejo was part of a large Mexican land grant awarded in 1842 to Juan Avila, a justice of the peace in San Juan Capistrano. The grant, one of 16 such ranchos in Orange County, was for just over 13,000 acres, and Juan Avila used the land to graze herds of cattle. Today, Don Juan Avila Middle School occupies a portion of the Aliso Viejo property, land where Avila's cattle roamed over 100 years ago.

Throughout the middle and late 1800s, American settlers found their way to Orange County, and by 1895, the Avila rancho had been split into parcels to be acquired by different individuals. In that year, Lewis Feeno Moulton, a pioneering rancher from Boston, purchased Avila's holdings. Moulton formed a partnership with Jean Pierre Daguerre, a Basque sheepherder, who took one-third ownership in the now 19,000 acre rancho known as the Moulton Ranch. Daguerre and Moulton soon grazed sheep and cattle and farmed the property, producing beans, grain, hay, and an assortment of smaller crops.

In 1908, Lewis Moulton married Nellie Gail, the daughter of a local El Toro storekeeper. The Moulton daughters, Charlotte and Louise, became active in running the ranch after Moulton died in 1938 at the age of 84. When Daguerre was tragically killed in a farming accident in 1911, his wife, Maria Eugenia Duguet Daguerre, along with her three daughters, assumed control of his share of the ranch. Ranch operations included the raising of livestock and tenant farming through the 1930s and during and after World War II. However, following the war, Orange County began to see an influx of new settlers, servicemen who were stationed at or processed through one of the number of military bases, including El Toro Air Station and the Santa Ana Army Air Base.

During the 1950s and 1960s, roads were added or extended into South Orange County, and sleepy communities such as San Juan Capistrano, Dana Point, and San Clemente began to grow. New communities, such as Mission Viejo, Leisure World, and Laguna Niguel began to transform the rural agricultural landscape into planned communities for the county's dynamic population boom. It was in the mid-1970s that Charlotte Moulton Mathis and her husband, Glen Mathis, along with Louise Moulton Hanson and her husband, Ivar Hanson, traded their interests in the remaining 6,600 acres of the Moulton Ranch to Mission Viejo Company for ranch property in other parts of California. In September 1976, the property closed escrow and Mission Viejo Company's team went to work to create what would eventually become the city of Aliso Viejo.

The community's new name, Aliso Viejo (or "Old Alder"), was chosen to represent the character of the land, as well as to create a connection with its very successful sister planned community

of Mission Viejo. However, unlike Mission Viejo, which was one of the first master planned communities in the nation, Aliso Viejo had the benefit of a decade of improvement in new town planning. Equally important, the world had changed in ways that would forever alter how people would live, work, and play. Planning was influenced by gas shortages, air pollution, urban sprawl, and the emergence of baby boomers. As such, the planners for Aliso Viejo approached their task of creating a new community with more knowledge, insight, and lessons learned to avoid past errors.

In the boom period of the 1960s, 1970s, and 1980s, creating a master planned community like Aliso Viejo was possible because of several unique factors. Most significant was the county's booming population, almost 60,000 people annually during the 1960s. Increasing population was a result of not only natural birth but also an influx of out-of-state in-migrants and population moving south from Los Angeles. Most of these new residents valued the variety of new homes, modern designs, and the more rural environment of South Orange County. A census taken in 1976 by Mission Viejo Company of the 25,000 residents of Mission Viejo showed that the majority of the community's working population commuted daily to central and northern Orange County jobs and a significant number drove as far as Los Angeles. The jobs were in North Orange County and Los Angeles, but homes were in South Orange County.

In addition to population increases, easier and more available access was being provided to the southerly parts of the county. Major thoroughfares, such as Interstates 5 and 405, were widened, improved, and extended. New arterial streets connecting to the freeways were built and new future roads, such as the San Joaquin Hills Corridor and Foothill Corridor, were being planned.

Despite these advantages, the development of Aliso Viejo faced some daunting challenges. Building a major community of this size would require hundreds of millions of dollars of funding that would pay for design and engineering, extensive infrastructure improvements, massive grading, and the cost of financing both the land and improvements. Mission Viejo Company was fortunate to have a strong source of financing that would allow the company to weather economic downturns and continue moving forward. In 1972, Philip Morris Companies, one of the largest consumer products companies in the world, purchased Mission Viejo Company and became a major player in new town development. During economic downturns, when conventional financing dried up, Mission Viejo Company was able to continue grading and building infrastructure, and as a result, was able to have completed lots and new homes ready when the economy improved.

The entitlement for Aliso Viejo was represented by the Aliso Viejo Planned Community Development Plan, approved by the County of Orange in 1979. This plan allowed for the development of 20,000 dwelling units; 3,400 acres for parks, open space, recreation, schools, and community facilities; and 900 acres for business parks. The approval also included a development agreement that conditioned Mission Viejo Company to provide all of the facilities and infrastructure that had traditionally been the responsibility of the County of Orange. Public facilities, such as fire stations, libraries, and parks, would all need to be funded without county funds.

In November 1982, the first housing units in Aliso Viejo were occupied. These units were sold for under $100,000; they were condominiums on the eastern perimeter of Aliso Viejo, where infrastructure, such as utilities and existing roads, were available. By 1984, retail businesses began to open, including the Target Center on La Paz Road. Grading for the new 900-acre Pacific Park business center began in 1985. It became home for companies such as UPS, Pepsi Cola, and Armorall. By 1990, Pacific Park would be home to over one million square feet of office, research and development, and light industrial space. During the first decade, from 1982 through 1991, Aliso Viejo grew by 5,000 households and nearly 16,000 people. During this period, it became the best-selling master-planned community in California, offering as many as 21 different housing developments.

By its second decade, Aliso Viejo began to see the creation of a unique community spirit. Family formations had increased significantly and year-round community events, planned by the Aliso Viejo Events Committee, began solidifying the family-oriented character of the community. During this period, new parks, part of 19 planned, began to open. Bike trails winding throughout

the community were connected to the Orange County Master Plan of Countywide Bikeways. Aliso Niguel High School, Aliso Viejo Middle School, and Foxborough Elementary opened, the first of seven schools operated by the Capistrano Unified School District.

During these years, Aliso Viejo was under the governmental jurisdiction of the County of Orange. However, management and maintenance of community parks, open spaces, and slopes were the responsibility of the Aliso Viejo Community Association (AVCA). This master association is comprised of delegates from all of the individual developments, both residential and nonresidential, within the community. The Aliso Viejo Advisory Planning Committee (AVAPC) was the design review arm of AVCA and reviewed and made recommendations on all planned developments prior to their submittal to the County of Orange for approval. AVCA continues to serve the community today, although AVAPC has been disbanded and its design review responsibilities turned over to the city after incorporation.

In September 1997, Philip Morris exited the real estate arena and sold Mission Viejo Company and its assets to Shea Homes, one of the largest privately owned real estate development companies in the country. Shea Homes is part of the J.F. Shea Company, which was founded in 1881 and played a major role in the construction of Hoover Dam and the Golden Gate Bridge. Shea continued to develop Aliso Viejo following the original master plan, but instead of only selling developed lots, Shea participated in the building of homes and business facilities. Today, Shea continues to complete projects on the last remaining parcels within the city.

By 2001, 111 years after the formation of the county, Aliso Viejo community leaders had received enough support to incorporate the community as the 34th city in Orange County. Incorporation did change some of the original boundary lines by ceding the Indian Hills and Indian Creek development areas to Laguna Hills and annexing portions of the Laguna Woods along the new city's northern boundary. The new city council members had long histories of involvement in the community and were informed about issues and how they might be solved. Despite the complexities of transitioning from a county controlled area, the transfer of authority was executed smoothly. Today, Aliso Viejo's city government is recognized as one of the most capable in the county.

Aliso Viejo is a city that is nearing the fulfillment of the dream of its early planners. About 46,000 people are now residents, and few parcels of land remain for development. The community is home to numerous corporate and regional headquarters, world-class business parks, and an international university complete with a state-of-the-art performing arts center. In a testament to the history of Aliso Viejo, the city has retained the seven-acre former ranch headquarters site. Gone from the fields are the hay wagons, tractors, and field hands. Left tucked away within the remaining buildings are the surviving farm implements, equipment, and tools used by the Moultons, their tenant farmers, and hired hands, waiting to be dusted off and someday put on display for future generations to see and appreciate.

One

THE EARLY YEARS
NATIVE AMERICANS,
EUROPEANS, AND RANCHOS

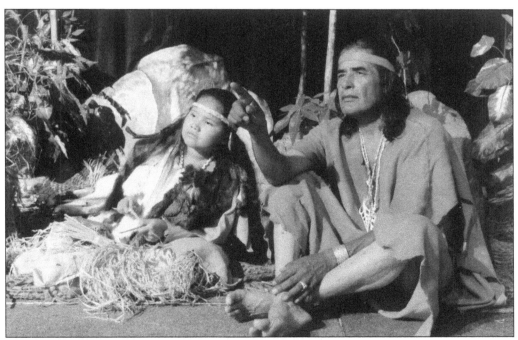

For nearly 2,000 years, before white men discovered the area now known as Orange County, the land was inhabited by Native Americans. The Acjachemen and Tongva were two of these tribes. The Franciscan missionaries called the Acjachemen "Juaneno" because of the tribe's association with Mission San Juan Capistrano. (Courtesy of Jacque Nunez and Journeys to the Past.)

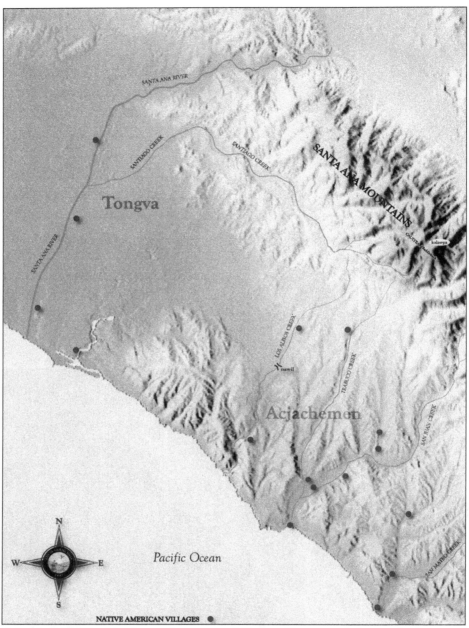

The Juaneno tribe lived in the southern part of Orange County and the northerly part of San Diego County and identify themselves today as the Juaneno Band of Mission Indians, Acjachemen Nation. Some scholars believe that these Native Americans came here through Alaska and, over thousands of years, spread themselves throughout the continent. Aliso Creek is generally recognized as the northerly boundary of the Acjachemen territory, with major groupings along the San Juan Creek and San Mateo Creek. In Aliso Viejo, the Juaneno had villages along Aliso Creek in the southern part of the Moulton Ranch. However, most of the tribe's villages were located along San Juan Creek near what is now Ortega Highway. Typically, these tribes lived in peace with each other and were in harmony with the land. (Courtesy of the City of Laguna Hills).

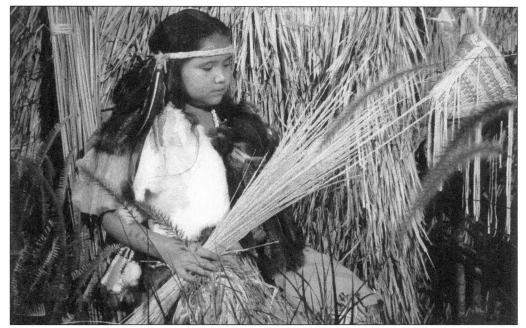

Clothing, tools, weapons, and shelter were made from what nature provided. To these early natives, the land provided all of their needs, including food, shelter, and clothing. The favorable climate, fertile soil, and available water supported a variety of plants that the Indians used for food, medicine, and shelter. Indian culture respected the land and nature, and tribes typically only took from their environment what they needed. (Courtesy of Jacque Nunez and Journeys to the Past.)

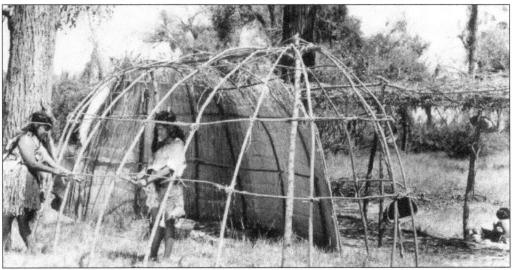

Indian villages were typically made up of tule-thatched huts called kiichas. These half dome structures were constructed with willow branches that were bent and tied together. An outside cover of locally available materials, such as cattails or reeds, formed an insulating layer. The top of the dome had an opening that provided an exit for smoke rising from the fire pit inside the hut. These fire pits were used for cooking and to warm the inhabitants. (Courtesy of Jacque Nunez and Journeys to the Past.)

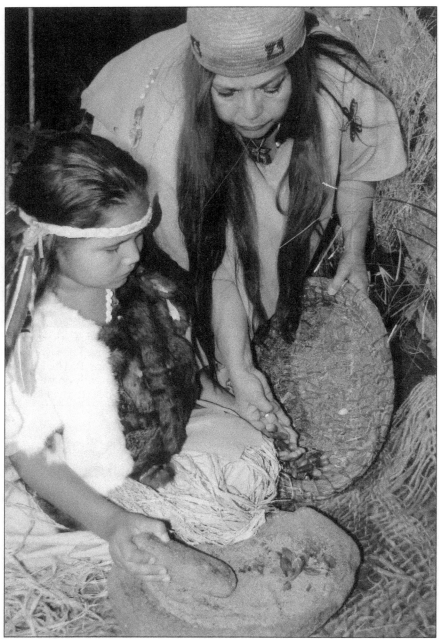

Native tribes lived primarily off the land, harvesting acorns, seeds, and plants, hunting small game, and fishing in the ocean and local lakes. Since oak trees were abundant in this area, acorns were plentiful and were a staple of the tribe diet. Granaries were built to store surplus supplies after the annual gatherings. At times, groups of people would move around the area, setting up temporary seasonal camps to obtain food not available in their permanent village. This included traveling in the fall to the mountains above Lake Elsinore to hunt deer and gather various plants. Some tribes would also collect abalone, one of the most significant trading commodities, along the rocky coastal shores. (Courtesy of Jacque Nunez and Journeys to the Past.)

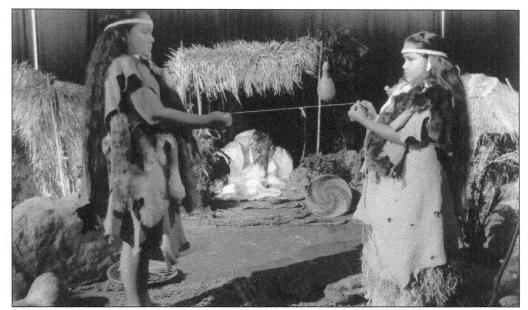

Indian villages were made up of families, with each member responsible for specific tasks depending on age and sex. Generally, young men provided food, shelter, and protection from predators. Boys accompanied the men, learning how to hunt, make weapons, and build huts. The women and girls prepared food, cared for the young, and generally saw to the care of the camp. Elder family members assisted wherever they could and served as advisors to the tribe. (Courtesy of Jacque Nunez and Journeys to the Past.)

According to the Juaneno Band of Mission Indians, Acjachemen Nation, there are over 1,900 certified members in the tribe, which has its headquarters in San Juan Capistrano. The Juaneno are one among several hundred non-recognized tribes that have petitioned the federal government for recognition as a federally organized tribe. (Courtesy of Jacque Nunez and Journeys to the Past.)

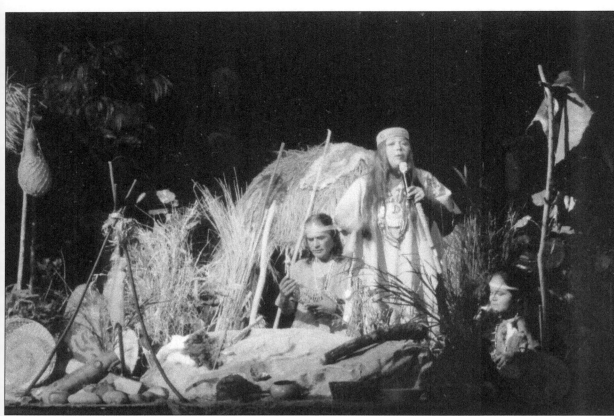

With the arrival of white men in Orange County in 1769, the native population's way of life was drastically altered. An expedition from San Diego to Monterey through the Saddleback Valley by Governor Gaspar de Portola resulted in new land grants being given to Portola and his men, who became permanent settlers. The new settlers and their culture quickly began to impact the ecological, social, and cultural customs of the Indians. Ancient ways began to fade as Spanish settlers exercised increasing control and influence. Today, there is an active resurgence within the tribes to restore and preserve native language, song, dance, and customs. In this photograph, Juaneno tribe educator Jacque Nunez performs a native song for a school group. (Courtesy Jacque Nunez and Journeys to the Past.)

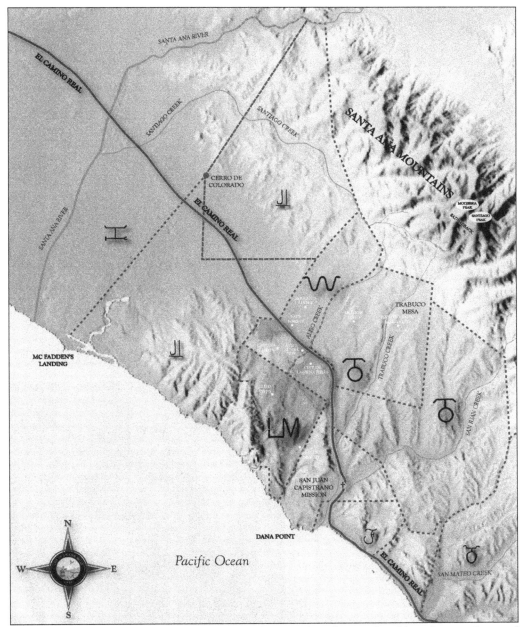

By 1842, Saddleback Valley, as we know it today, was largely populated by white settlers and Spanish families who had received land grants through Spain or from the Mexican governor after Mexico declared its independence. Mission San Juan Capistrano lost much of its land holdings following Mexican independence. A portion of the land, known as Rancho Niguel, was awarded to Juan Avila by Gov. Juan B. Alvarado. The property was 13,316 acres and was adjacent to Rancho San Joaquin and Rancho Canada de los Alisos. These three ranchos formed what are now the communities of Irvine, Corona del Mar, parts of Laguna Beach, Lake Forest, Laguna Hills, Laguna Niguel, and Aliso Viejo. Together, these parcels totaled nearly 73,000 acres (or about 14 percent) of the area of Orange County. (Courtesy of the City of Laguna Hills.)

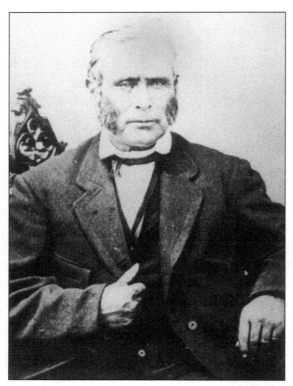

Juan Avila was the son of Antonio Ygnacio Avila, a grantee of Rancho Sausal Redondo near Los Angeles. He was a "judge of the plains" at Los Angeles in 1844, as well as a justice of the peace in San Juan Capistrano in 1846. After his wife, Soledad Yorba de Avila, died of smallpox in 1867, Avila sold Rancho Niguel to John Forster. Avila passed away in 1895. (Courtesy of the O'Neill Museum.)

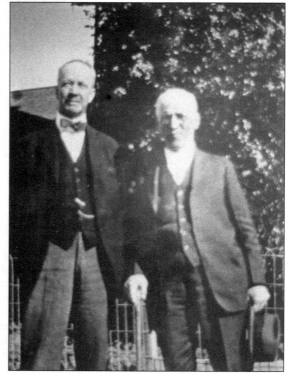

In 1895, Lewis Fenno Moulton (left) acquired the Rancho Niguel property. In 1908, he went into partnership with Jean Pierre Daguerre (right), a Basque sheepherder who came to the United States seeking his fortune in 1874. After his purchase of Rancho Niguel, Moulton acquired additional land and expanded the ranch to about 22,000 acres. (Courtesy of the O'Neill Museum.)

18

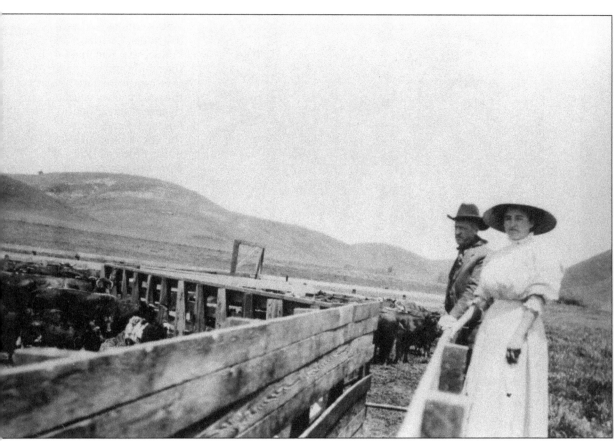

The Moulton-Daguerre partnership changed when J.P. Daguerre was tragically killed in a farming accident in 1911. Daguerre's wife, Maria Eugenia, shown in this photograph with Lewis Moulton, took over responsibility for her husband's share of the ranch. By 1908, Lewis Moulton was a successful rancher and married Nellie Gail, the daughter of the El Toro storekeeper, John L. Gail. Nellie Gail Mouton took an active interest in the ranch and continued to operate it after the death of Lewis Moulton in 1938. In a testament to Nellie Gail Moulton, the Presley Company named its equestrian home development in Laguna Hills after her. Today, Nellie Gail is one of the most desirable residential locations in Saddleback Valley. She passed away in 1972 at the age of 93. (Courtesy of the Saddleback Area Historical Society.)

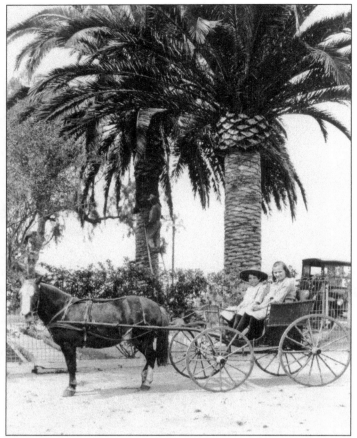

The Moultons had two daughters, Charlotte and Louise, who remained with the family and eventually oversaw the operations of the ranch. They educated themselves in animal husbandry and, after the sale of their interest in the ranch in 1976, moved to new ranches in California. The main business of ranchos was raising cattle livestock for sale in the market. In this early photograph, the girls pose in their horse-and-buggy rig. (Courtesy of the Saddleback Area Historical Society.)

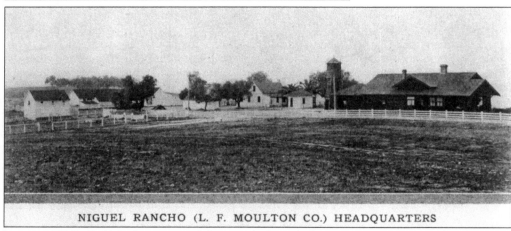

NIGUEL RANCHO (L. F. MOULTON CO.) HEADQUARTERS

Lewis and Nelli Gail Moulton operated their ranch through the L.F. Mouton Company headquarters, located in what is now a portion of Laguna Hills near the Laguna Hills Mall. Originally, the ranch was devoted to raising sheep and some agricultural products. In 1912, the ranch changed to cattle and also leased land to farmers, who raised grain and beans. The Moulton Ranch was highly successful in its cattle raising and was known for its high-quality Durham beef. (Photograph courtesy of the Moulton family and the City of Laguna Hills.)

Life on the Moulton Ranch was not all toil. These ladies are enjoying eating watermelon on a warm day at the ranch. Plots of land were leased to tenant farmers who grew a variety of crops that were sold at local markets. These tenant farmers often lived on the ranch in farmhouses scattered along dirt roads. Many of the farmers came into the area in the late 1800s, representing a new wave of Americans. Hay, barley, beans, walnuts, and varieties of fruits were major crops. However, cattle, hogs, and other livestock continued to graze on the hills of the ranchos. Tenant farmers on the Aliso Viejo ranch continued to pursue farming operations well into the 1980s, before development. The location of this photograph is somewhere near the existing Aliso Viejo Ranch, looking southwest toward Laguna Niguel. (Courtesy of First American Title Insurance Co.)

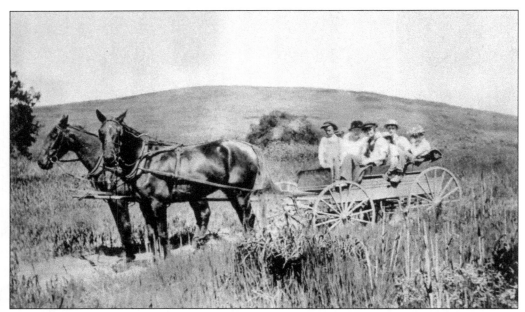

Horse-drawn wagons were often used to transport farm hands into the fields, move produce to market, or convey goods and equipment to and from the ranch. Sometimes the wagons served as recreation for the children of local families, as can be seen in this photograph from around 1913. Dirt roads crisscrossed the Moulton Ranch, providing adventurous rides through a variety of terrain, including hills and valleys. (Courtesy of First American Title Insurance Co.)

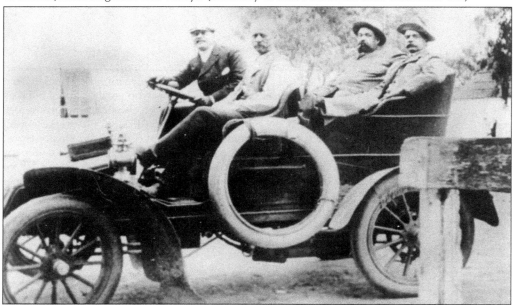

In 1910, Lewis Moulton, in the passenger seat, is taking a test drive with a car salesman. In the back seat, behind the driver, are Dwight Whiting Sr. and friend Bob Denis. At this time in America, the horse and buggy was quickly giving way to motorized vehicles. It is thought that Moulton was one of the first automobile owners in South Orange County. (Courtesy of the Saddleback Area Historical Society.)

Two

THE DEVELOPMENT ERA
MASTER PLANNING A NEW TOWN

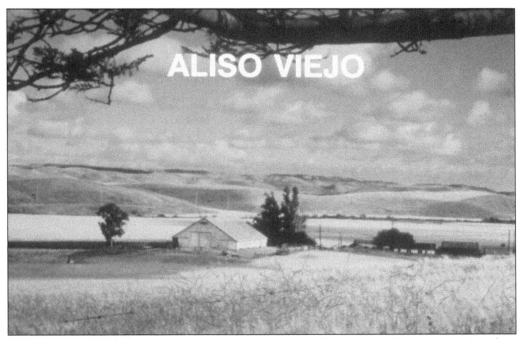

In September 1976, Mission Viejo Company purchased 6,600 acres of the remaining Moulton Ranch for the planned community of Aliso Viejo. In a few short years, this vast landholding would move from the serene farmland depicted in this photograph to a vibrant, active community.

The master developer of Aliso Viejo was Mission Viejo Company, best known up to that time for the development of Mission Viejo, a 10,000-acre community built on the vast O'Neill ranch holdings several miles inland along Interstate 5. Since the underlying land was part of Rancho Mission Viejo, the development company adopted as their logo the stylized cattle brand of the rancho.

Mission Viejo Company began in 1963 when the O'Neill family decided to begin development on the part of their ranch that would be directly accessible to the new Interstate 5 freeway. The company's headquarters were located on La Paz Road, just east of the freeway off ramp, and included an adjacent model home compound and neighborhood shopping center complete with its own post office.

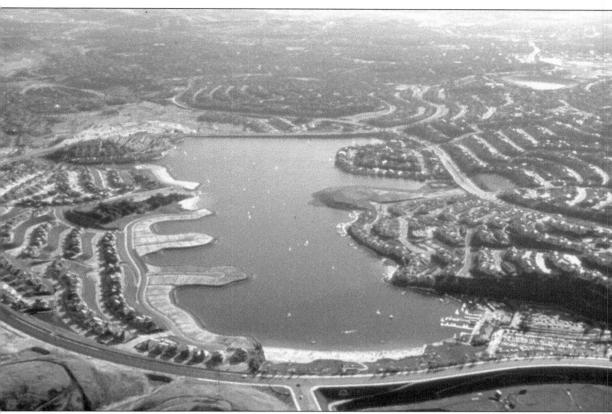

Mission Viejo, at 10,000 acres, was significantly larger than Aliso Viejo. It was planned for 30,000 dwelling units and 90,000 people, compared to 20,000 dwelling units and about 48,000 people for Aliso Viejo. Mission Viejo Company planners gained some valuable experience during the development of Mission Viejo, and this was carried over when the company purchased the Moulton Ranch and created Aliso Viejo. One idea that was proposed and eventually abandoned was to replicate a manmade lake, such as Lake Mission Viejo (pictured), in lower Wood Canyon in Aliso Viejo. The lake would have been accessible to the public and was expected to help lower traffic to the south coast beaches.

In 1969, Philip Morris expanded into the real estate development business by purchasing a controlling interest in Mission Viejo Company and an option to purchase the remaining shares of the company. At the time, real estate development was considered a major emerging industry because of the demand for housing by baby boomers, those born in the recovery-period years after World War II. (Courtesy of Mission Viejo Company.)

Philip Morris sought diversification of its consumer products businesses, and Mission Viejo Company was at the right place at the right time. Known primarily as a tobacco company, Philip Morris considered participation in real estate in the early 1960s. This Mission Viejo Company photograph was prepared to depict Philip Morris products and homebuilding as part of the same family. (Courtesy of Mission Viejo Company.)

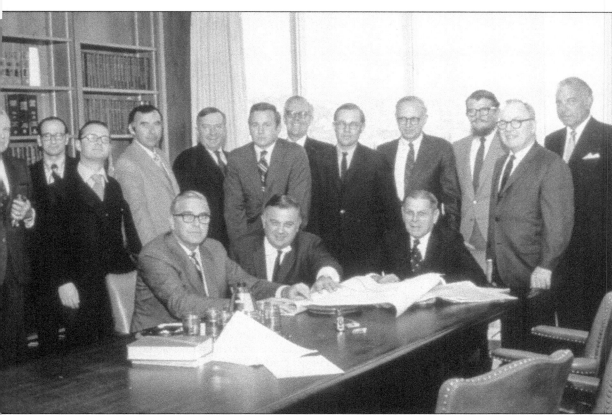

In 1972, Philip Morris bought the remaining shares of Mission Viejo Company, which became a wholly owned subsidiary of the New York conglomerate. Major shareholders included the O'Neill family, represented by Richard J.O'Neill, pictured in the middle of the first row. Standing fourth from the left is Phil Reilly, president of Mission Viejo Company, and sixth from the left is Tony Moiso, O'Neill's nephew and an executive with Mission Viejo Company. Philip Morris also provided funding for Mission Viejo Company to pursue additional land acquisitions. In 1976, these funds were used to purchase the 6,600-acre Moulton Ranch parcel, and in 1977, the 25,000-acre Phipps Ranch in Denver, Colorado, which was named Highlands Ranch. (Courtesy of Mission Viejo Company.)

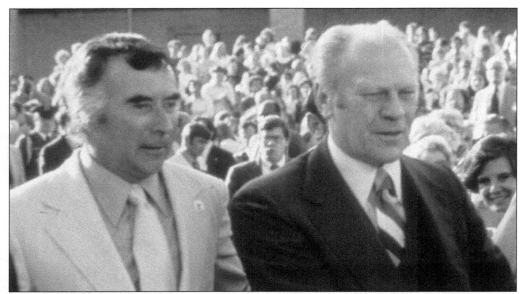

The drive behind Mission Viejo Company that culminated in the acquisition of the Moulton property is credited to company president Philip J. Reilly. A University of Southern California graduate and real estate attorney for Rutan & Tucker in the 1960s, Reilly took the reins of Mission Viejo Company after the departure of the company's first president, Donald Bren, in 1967. In this 1976 photograph, Reilly escorts Pres. Gerald R. Ford to a commemoration ceremony in Mission Viejo celebrating the country's 200-year anniversary. (Courtesy of Mission Viejo Company.)

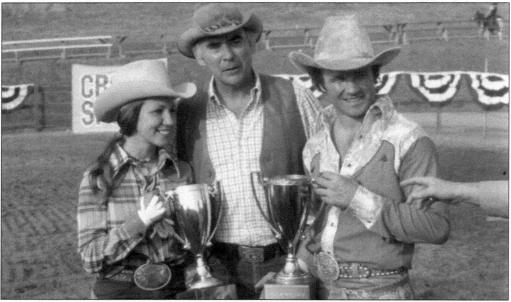

In the early years of the company, before it was acquired by Philip Morris, comfortable western clothing was common attire at the company's office. In this 1975 photograph, company president Phil Reilly participates in a CBS television rodeo award ceremony. In 1984, after acquiring the Moulton Ranch and overseeing its start of development, Reilly relocated his office to the Denver, Colorado, area to head up the company's last acquisition, Highlands Ranch. (Courtesy of Mission Viejo Company.)

Jim Gilleran succeeded Phil Reilly as president of Mission Viejo Company in 1987 and made a major imprint on Aliso Viejo. Originally an auditor with Philip Morris, Gilleran joined Mission Viejo Company in 1969 and assisted in making it into a well-structured subsidiary of the New York consumer products company. Following the acquisition of Aliso Viejo, Gilleran and his team of planners, designers, and engineers completed the plans for this new town and obtained approvals from the County of Orange and multiple jurisdictional agencies. Following this effort, Gilleran oversaw the construction and sale of the first homes in the community, as well as schools, shopping centers, and businesses. In 1986, Gilleran is seen receiving the World Class Community award at the 10th annual conference of the International New Town Association. (Courtesy of Mission Viejo Company.)

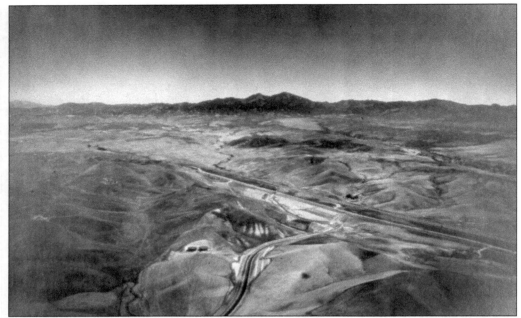

In this 1964 photograph, South Orange County can be seen as primarily an agricultural and ranching region with a number of major ranches that were formed over the past several hundred years. In this photograph, Mission Viejo is viewed from what are now Crown Valley Parkway and the San Joaquin Hills Transportation Corridor. Saddleback Mountain is visible in the background.

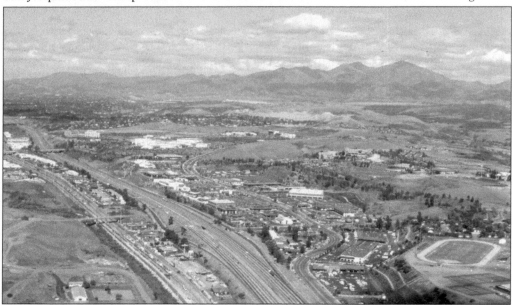

By the mid-1970s, when the Moulton family sold their last remaining property to Mission Viejo Company for the Aliso Viejo community, the population influx into south Orange County had fostered rapid growth, especially along Interstate 5. As this land began filling with houses, businesses, and community facilities, the pressure for developing remaining infill parcels such as Aliso Viejo increased.

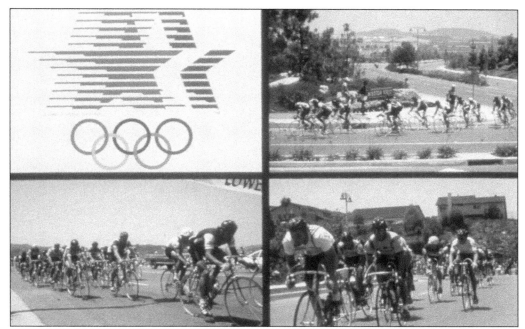

Mission Viejo Company and its master-planning achievements were showcased in the 1984 Olympic cycling event, held in Mission Viejo and televised worldwide. Aliso Viejo, through the efforts of the project's proponent, Los Angeles Rams football coach George Allen, had almost become the site of the US Olympic training center during this period. Unfortunately, Allen died just as the project was nearing final approval, which caused supporters to drop the idea.

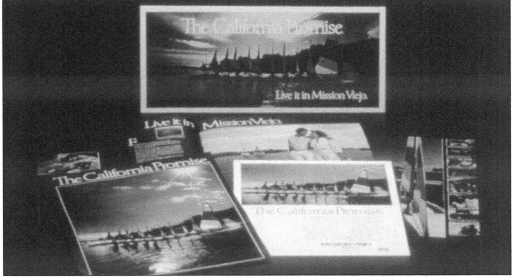

Mission Viejo Company cashed in on the "California promise" with its hugely successful marketing campaign for Mission Viejo. However, with this success came the realization that Aliso Viejo was a different property with different opportunities and challenges. The world and the environment for development had changed significantly in the 10 years since Mission Viejo was started and planning began on Aliso Viejo.

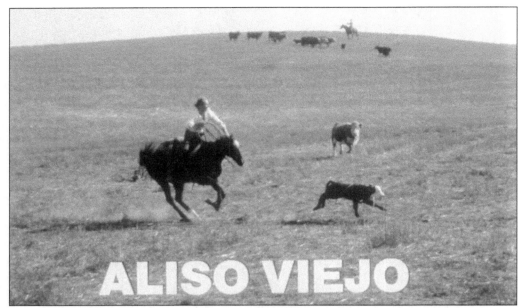

ALISO VIEJO

Upon acquisition of the property, Mission Viejo Company established the Aliso Viejo Company to continue ranch operations. It was important to continue operating the property as a ranch to provide maintenance, security, and revenue to offset property taxes and operating costs. In this 1979 photograph, ranch caretaker Don Barnes is seen galloping across the hills to rope a stray calf. (Courtesy of the Barnes family.)

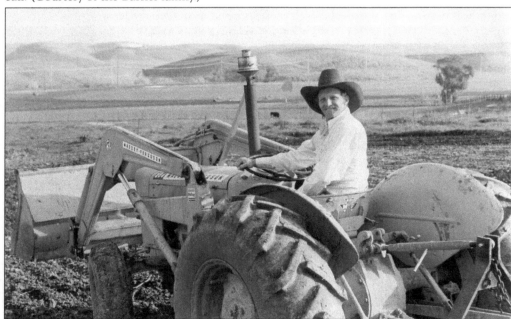

An avid horseman and rancher, Barnes was equally adept at running any equipment on the ranch or tending to any type of livestock, including cattle, goat, and sheep. The ranch had many different types of tractors and bulldozers, which Barnes enjoyed operating. (Courtesy of the Barnes family.)

32

In this 1981 photograph, Don Barnes, on the right, and Dan Kelly participate in a game of horseshoes. Kelly worked for Mission Viejo Company during the planning and zoning period and left to join Rancho Mission Viejo. Many individuals who worked on the Aliso Viejo project went on to form their own companies or to extend their careers with other well-known organizations in Orange County. (Courtesy of the Barnes family.)

The Aliso Viejo Ranch headquarters served as the central point for ranch operations. The ranch bunkhouse, on the right, served as the ranch office. In the background, the existing ranch barn can be seen. All of the hills behind the barn are now occupied by various housing developments, including California Reflections, which is adjacent to the ranch headquarters. (Courtesy of the Barnes family.)

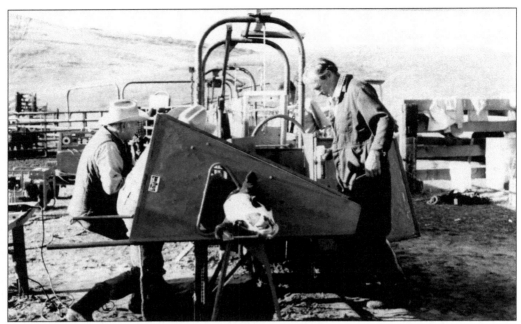

Cattle operations were an important part of the ranching activities on the Aliso Viejo property in Lewis Moulton's time and after acquisition by Mission Viejo Company. Cattle required inspection and attention to their health. In this photograph, a steer is receiving inoculations by a veterinarian on the right, while Louie Etcheberria, one of the remaining farmers on the ranch, provides assistance.

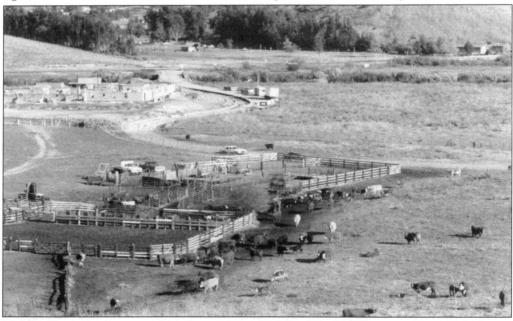

Mission Viejo Company continued to operate the Aliso Viejo land as a working ranch during the entitlement and permitting period. Cattle pens, set up south of Aliso Creek Road and on the west side of Aliso Creek, were used for branding, inoculations, dehorning, and other livestock care operations. (Courtesy of the Barnes family.)

In addition to cattle, the ranch was actively farmed, as is depicted by this hay thresher in 1977 working fields that are now occupied by Aliso Niguel High School. These activities continued through the 1980s and into the early 1990s. Many pieces of farming equipment could be seen on the ranch, including tractors, scrapers, backhoes, and hay- and produce-transport trucks.

In addition to running the ranch, Don Barnes took care of numerous horses and often could be seen exercising the animals on the ranch. The ranch barn, pens, and trails were an ideal location for riding, and often employees with the company eagerly looked forward to a day of riding on the ranch—for work or just for recreation. (Courtesy of the Barnes family.)

In 1978, an errant Skyhawk fighter jet crashed just north of the property during the plane's landing approach into El Toro Marine Corps Air Station. While there were no fatalities, the jet was totally destroyed, as were several housing units in the Leisure World development where the jet crashed. The remnants had to be gathered and transported by truck to the air station for post-crash evaluation. Aliso Viejo's ranch headquarters served as a trucking way station to inspect the load before it entered the public highways. Between 1976 and 1999, Aliso Viejo was under the flight path of Marine Corps aircraft landing at El Toro. A variety of planes flew over the ranch during those years, including Air Force One, giant C-5A cargo planes, and fighter jets. (Courtesy of the Barnes family.)

During the three-year period after acquisition, extensive planning began to design and entitle Aliso Viejo for development. In this 1978 photograph, the property and its surrounding roads reflected the sleepy, uncongested environment of most farming communities. El Toro Road, separating Aliso Viejo from Leisure World on the north, often saw as many farm vehicles as family sedans.

In 1978, driving south on Moulton Parkway, just past Leisure World, provided a panorama of fields, farmhouses, and country roads. As a two-lane country road, Moulton Parkway was typical of most of the roads in south Orange County. Traffic congestion, four-way signalized intersections, and arterial highways were yet to come.

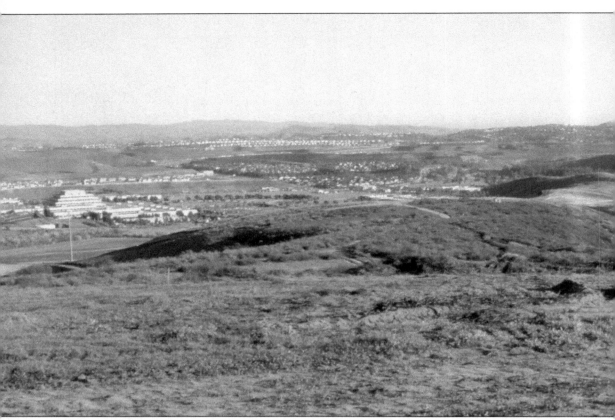

When the Moulton Ranch property was acquired in 1976, it did not have many neighbors, with the exception of the Ziggurat. Built in 1969 as the future headquarters for North American Rockwell, a major aerospace firm then headquartered in El Segundo, the building was never occupied by the firm. It was eventually acquired by the federal government for use by various agencies, including the Social Security Administration and Internal Revenue Service. Popularly referred to as the Ziggurat for its resemblance to Mesopotamian temples, the facility was often used as a movie location. The cult movie *Death Race 2000*, with then-unknown actor Sylvester Stallone and *Kill Bill* star David Carradine, utilized the Ziggurat as a background location. Today, the facility continues to be used for federal government agencies. This photograph was taken from the approximate location of Aliso Viejo Parkway and Liberty.

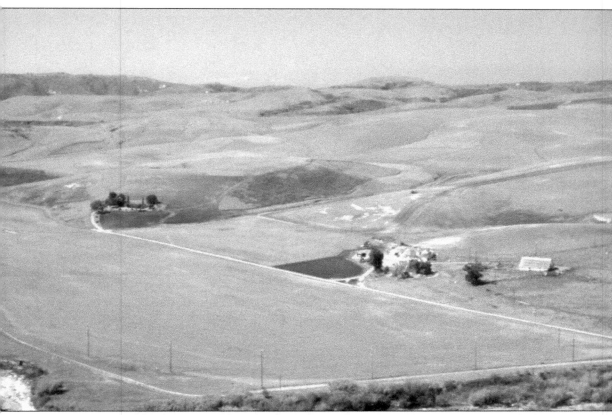

The Moulton Ranch had few structures on its 6,600 acres. In addition to the barn, sheds, and bunkhouse (on the right in this 1980 photograph), the Moulton family built a residential compound on what is now the San Joaquin Hills Transportation Corridor. The family property included a California ranch–style residence, complete with swimming pool and large outdoor area for entertaining. This compound (on the upper left) was razed with the grading of this planning area. By the late 1980s, much of Aliso Viejo was being mass graded for housing, a result of a booming economy and rapid growth in Orange County. Much of the growth was being directed to South Orange County, where land was plentiful and homebuyers had a large selection of homes and locations to choose from. Aliso Viejo was a destination of choice for many prospective homebuyers.

In 1976, access to the Aliso Viejo ranch headquarters was from Moulton Parkway along a winding dirt road and partially paved entry. Today, the entry is located just off Aliso Viejo Parkway (called Laguna Hills Drive at that time) and connects to Park Avenue, the street separating the Aliso Viejo middle school and the existing ranch. This photograph was taken in 1978 from Moulton Parkway just north of Glenwood Drive.

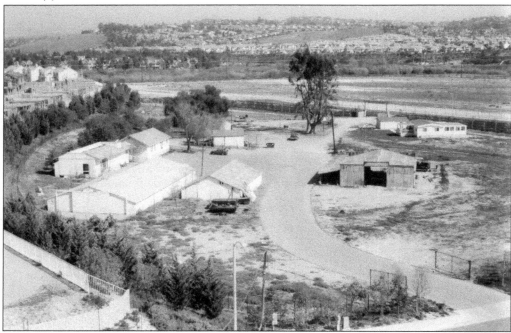

This photograph, taken in 1991, shows the seven-acre ranch from the adjoining neighborhood to the west. At the time, the old metal building that housed farm equipment was still standing (on the right). However, the gasoline pump used to fuel farm vehicles had been removed years earlier. The original ranch gate, with its distinctive overhead sign, was also still in place. Note that the Aliso Viejo Middle School was not yet built.

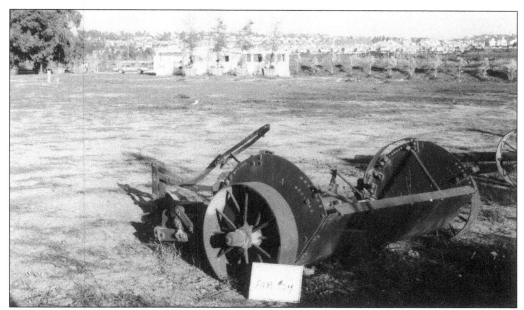

The ranch became the repository for many pieces of equipment, hand tools, and other artifacts used over the years to farm and maintain the property. This piece of field equipment, photographed in 1991, shows its identification number, which is used for cataloging purposes. Nearly all of these pieces were photographed, tagged, and listed in an inventory taken by Mission Viejo Company in 1991. (Courtesy of the City of Aliso Viejo.)

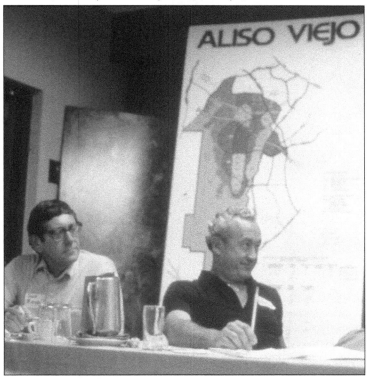

The team from Mission Viejo Company that created the vision and plan for Aliso Viejo included numerous disciplines needed to address the complexity and challenges of this project. Overall team management was the responsibility of James G. "Jim" Gilleran, on the right, then executive vice president. Leading the engineering and planning team were Jack G. Raub, president of the engineering firm bearing his name. Raub's firm originally worked under contract but was bought by Mission Viejo Company in 1984 after the entitlement of the Moulton property. (Courtesy of Mission Viejo Company.)

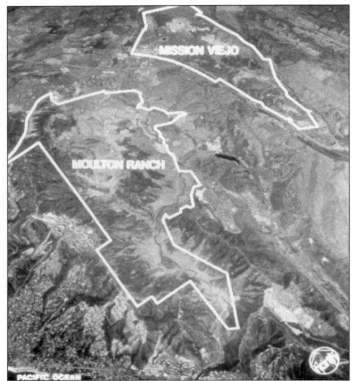

While Mission Viejo and Aliso Viejo were only a short distance apart, their plans were significantly different. Some of the differences were caused by property characteristics such as topography, and some of the differences were caused by the social and political climate. In the early 1960s, when Mission Viejo was planned, the only neighbors were cattle and cowboys. In the late 1970s, Aliso Viejo could count nearly 24 different interest groups that had, or wanted, a say in the eventual plan.

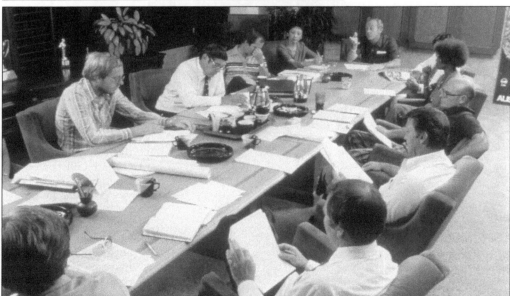

The planning and zoning for Aliso Viejo occurred over the three-year period from late 1976 through April 1979 and included various departments within Mission Viejo Company. Jim Gilleran, at the end of the conference table, conducts a project review meeting with Jack G. Raub, second from the left. On Raub's right is Steve Delson, who headed up the development of Aliso Viejo after Gilleran and Raub retired. (Courtesy of Mission Viejo Company.)

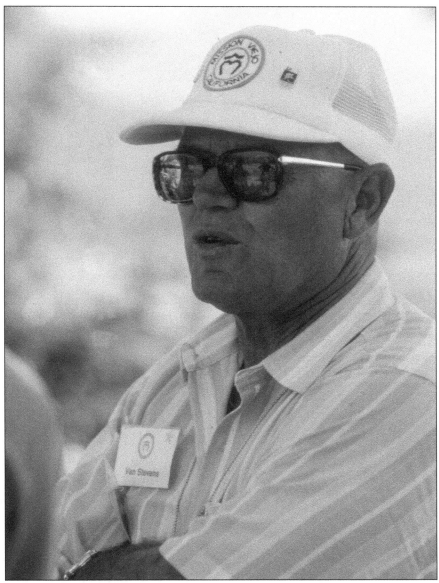

In the initial efforts to determine the proper development plan for Aliso Viejo, Mission Viejo Company concluded that there needed to be extensive thought and due diligence before placing one line to a development plan. Unlike the Mission Viejo community plan, which was a direct response to the problems associated with the lack of good planning within communities in other areas of Southern California, including Orange County, the Aliso Viejo community plan faced unique and more serious issues. The no-growth movement, fuel shortages, higher costs of development, coastal zone restrictions, and the fact that no residential buildings could be constructed under the flight path into El Toro's air base were examples of new challenges that called for different approaches. Van Stevens, head of planning for Mission Viejo Company, was instrumental in guiding the preparation of the plan and obtaining approval from the County of Orange. In this photograph, Stevens attends the 1984 Olympic cycling event held in Mission Viejo. (Courtesy of Mission Viejo Company.)

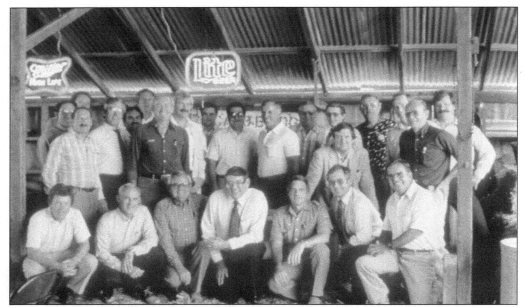

The smaller ranch barn was often used for meetings and social events for company employees. Senior executives that developed the Aliso Viejo development plan pose for a photograph in the ranch barn. In the middle of the first row is Jack Raub, in charge of engineering, and on his left is Harvey Stearn, in charge of residential development. In the second row, third from the left, is Jim Gilleran, and on his left is Jim Huesman, the company's chief financial officer.

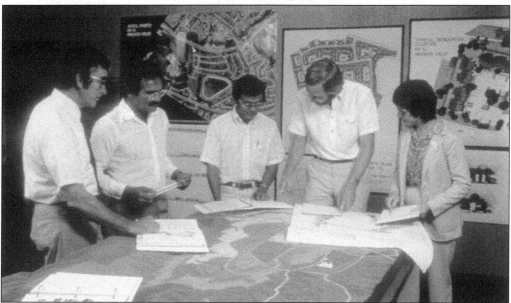

Starting in late 1976, Mission Viejo Company began preparing planning, technical, environmental, economic, financial, and marketing studies for the development of Aliso Viejo. In this photograph, Steve Delson reviews engineering issues with engineering managers Joe Holleran (on the far left), Rudy Garcia (second from left) and several unidentified technicians. Note the early study model of Aliso Viejo in the foreground.

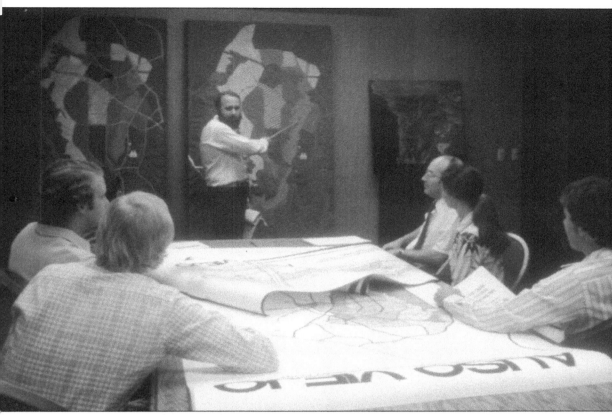

Many of the design decisions that created the Aliso Viejo community emerged from team meetings involving multiple disciplines. Architectural themes in the community reflected the desire for scale and diversity. Multiple styles of architecture were introduced that contrasted with the Spanish themes used almost universally in Aliso Viejo's sister development of Mission Viejo. Landscaping themes were designed to partially screen residential development from surrounding neighborhoods and arterials. More formal landscaping was employed within business parks to soften the view of concrete buildings while allowing for signage and building identity. In this photograph, Mike McLaughlin, a design manager with Mission Viejo Company, leads a team in reviewing design concepts.

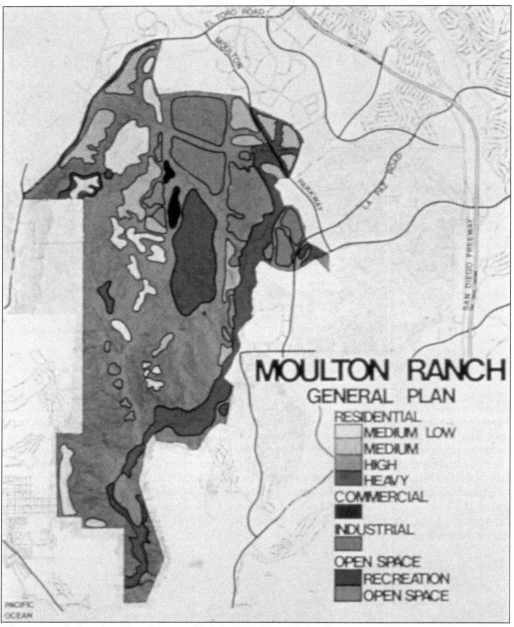

The original plan for Aliso Viejo called for 10,000 total dwelling units. However, the total was increased to 20,000 in order to make the development of the project financially feasible. In exchange, Mission Viejo Company agreed to enter into a development agreement that would preclude any financial burdens on the County of Orange for public infrastructure. As a result, the developer provided land and funding for the city's library, sheriff's substation, fire station, streets, drainage, and water-treatment facilities. Aliso Viejo's master plan, approved by the County of Orange in 1979, called for 36 percent of the land to be devoted to residential neighborhoods; 51 percent to parks, recreation, schools, and community facilities; and 13 percent to business, office, and retail.

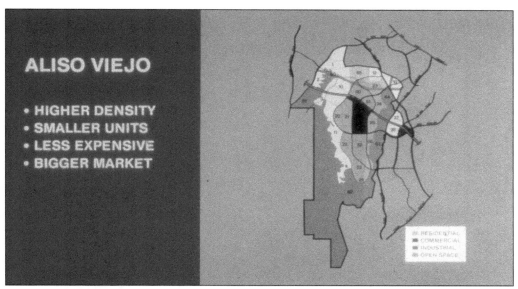

Early planning focused on using the rolling topography to best advantage and balancing areas devoted to residential, commercial, and community facilities. Market studies indicated that buyers for residential housing wanted less expensive units and more open space. As a result, early housing products were typically smaller with higher densities but with abundant landscaped areas in and around the developments.

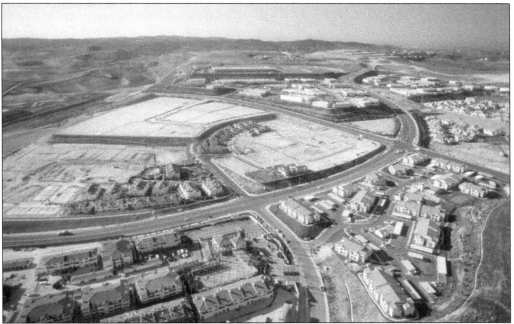

Aliso Viejo was the first planned community in California with a master plan that provided for a balance between projected jobs and the projected residential workforce. The plan called for 22,000 onsite jobs and 20,000 residential dwelling units, making it possible for residents to live, work, and play in the same locale. In this photograph, the graded site for Fluor Corporation is visible in the upper left.

47

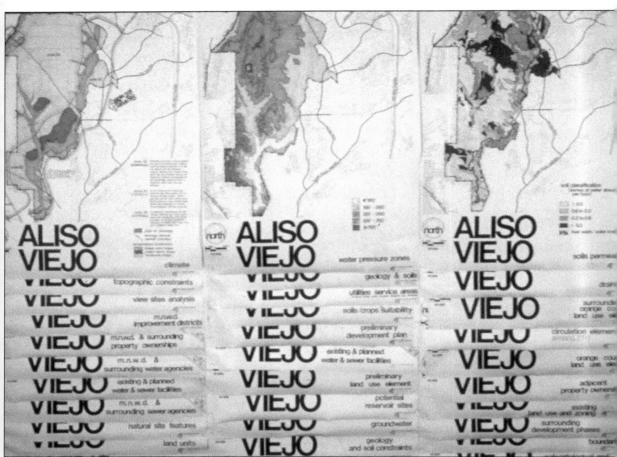

To prepare the development plan, extensive technical studies and evaluations were needed before designs could be completed. Chief among these studies was the environmental impact report that assesses the impact of the development on the surrounding environment. Jack G. Raub Company personnel prepared studies of air quality, noise, archeologically significant areas, and water runoff, among other key environmental factors. The resulting Environmental Impact Report (EIR) 088 required numerous binders and shelves to store, but it was one of the most thorough environmental impact reports submitted to the County of Orange. The EIR was approved in 1979 and was utilized until the City of Aliso Viejo incorporated in 2001 and prepared its EIR as part of the adoption of the city's first general plan.

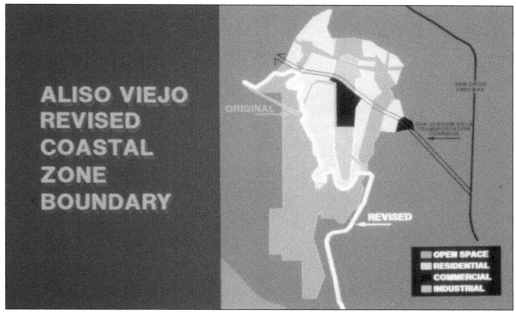

When the California Coastal Act was approved by the legislature in 1976, the coastal zone boundary was placed through Aliso Viejo. This line did not correspond to the commission's own rule for establishing these boundaries, and it was challenged by Mission Viejo Company. By staking wide ribbons of colored Visqueen representing where the boundary line was drawn by the commission, where the line should be located by the commission's definition, and by flying legislators over the property in helicopters, support was gained for revising the line.

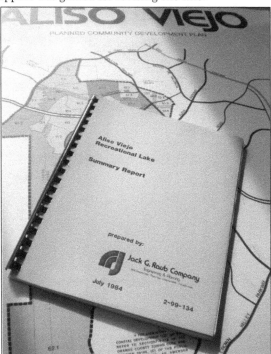

In 1984, a feasibility study for a recreational lake in a portion of lower Wood Canyon Regional Park was completed. Two alternative lakes were studied and found to be technically feasible utilizing an earthen dam along the southern entry to Wood Canyon, just below Soka University. A 220-acre lake and a 116-acre lake, similar to 125-acre Lake Mission Viejo, would provide extensive recreational opportunities for the community and region. However, the project was never pursued. (Courtesy of Steve Delson.)

49

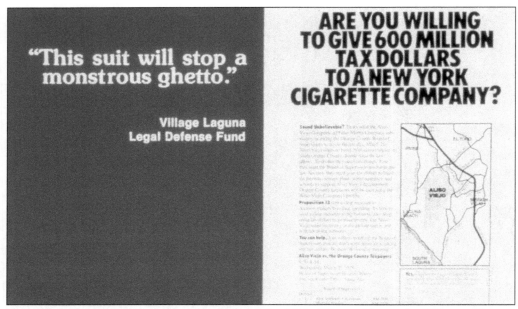

Not all was smooth sailing for the planners of Aliso Viejo. The rapid growth of Orange County was taking its toll on regional infrastructure, creating traffic congestion and crowded schools. This announcement focused on county taxpayer funding of Aliso Viejo improvements and was distributed just prior to the county board of supervisors' approval of the Aliso Viejo Development Plan.

To counter the challenge and criticism, Mission Viejo Company mounted a campaign to explain its plan. Depicted as "sanctioned" growth, the Aliso Viejo development plan called for a balanced community, whereby various portions of the land were devoted to living (residences), working (business park areas), and playing (parks and open spaces).

Three

THE DEVELOPMENT ERA
DEVELOPING THE LAND

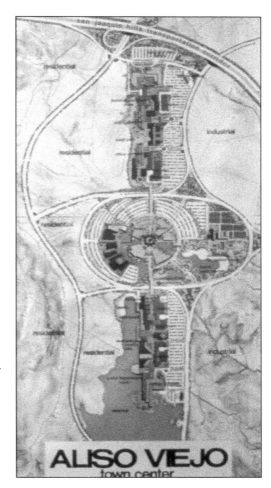

Aliso Viejo planners explored various approaches to the design of the central area of the property, now known as the Aliso Viejo Town Center. In 1973 and 1979, the Middle East fuel embargos focused attention on the need to reduce vehicle usage. This, combined with increased concern about air pollution from vehicle emissions, caused planners to design more walkable communities.

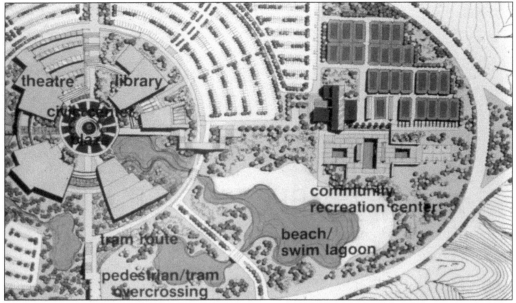

In this early concept of the Town Center, a civic center plaza is surrounded by support facilities and amenities, all serviced by a tram system, walking paths, and bicycle trails. Mission Viejo Company also studied the feasibility of fountains, ponds, and small lakes within the Town Center. However, because of the cost of building and maintaining water features, the final design included only a large formal fountain

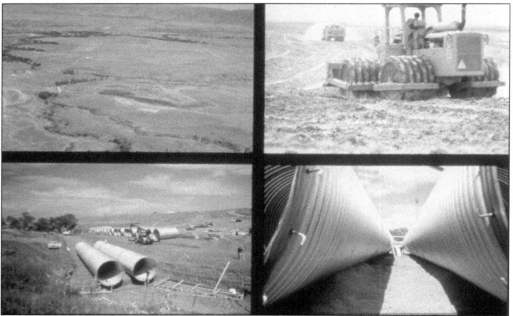

By the time the Aliso Viejo plan was approved by the county board of supervisors in 1979, approximately $40 million had been spent on the property, without the sale of a single home. Hundreds of millions of dollars were to follow in major infrastructure improvements, including storm drains (shown), mass grading, more technical studies, and preparations for home construction and business land sales.

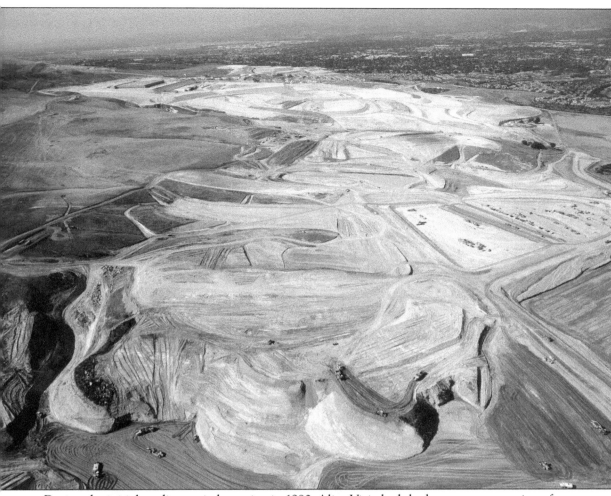

During the initial grading period, starting in 1980, Aliso Viejo had the largest concentration of grading equipment in any single location within California. Referred to as mass grading, these operations followed explicit grading plans prepared by licensed geotechnical engineers. Because of the size of Aliso Viejo and the significant amount of dirt movement, the engineers were able to "balance on site," meaning that there was no need to export dirt off the property to other locations. Total mass grading on Aliso Viejo was equivalent to the digging of six Panama canals—about 120 million cubic yards of earth. Initial grading began along the eastern and northern areas of Aliso Viejo, closest to existing utilities, storm drains, and entry roads. Because the topography of the property was highest on the west side and fell (or "terraced") toward the east, grading design incorporated a series of terraces. (Courtesy of Aerial Eye, Inc.)

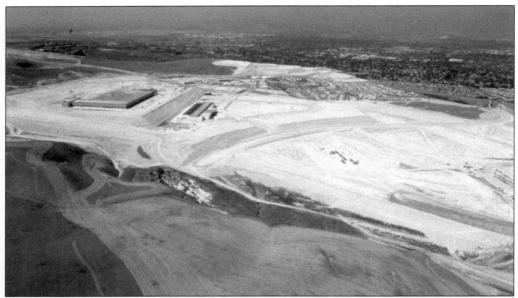

All of the soil in Aliso Viejo was under water during prehistoric periods and contains significant amounts of marine-life materials. The abundance of this material is what produces the powdery, white characteristics, referred to as diatomaceous soil, used in a refined state for swimming pool water filtration. Significant soil remediation was required as a part of the grading to meet geotechnical standards required for development. The UPS facility is visible in the upper left. (Courtesy of Aerial Eye, Inc.)

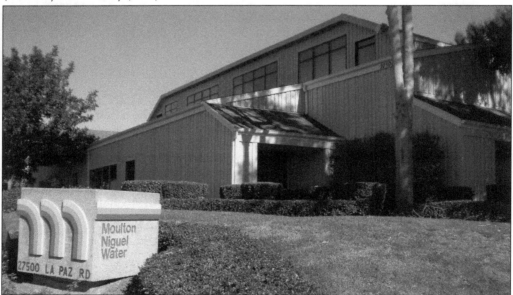

One of the most important utility providers for Aliso Viejo is the Moulton Niguel Water District (MNWD). During the development of the community, MNWD worked with Mission Viejo Company to plan and operate the water systems necessary for growth. Reclaimed water for irrigation of slopes and other common areas was one of the important programs introduced into Aliso Viejo and overseen by MNWD. Pictured is MNWD's headquarters in Laguna Niguel.

Much of the strategy used in establishing the types, sizes, and pricing of housing in Aliso Viejo was shaped by economic and demographic trends occurring during the 1970s and 1980s. Aliso Viejo's lower-priced housing, close location to the ocean, and inviting hillside properties were very attractive to young families and singles. For many years in the 1980s, Aliso Viejo was one of the fastest selling planned communities in the country.

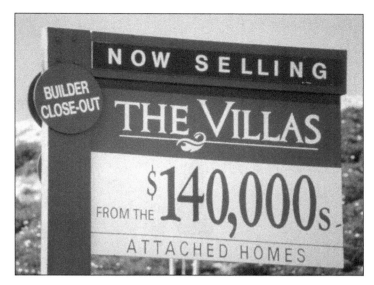

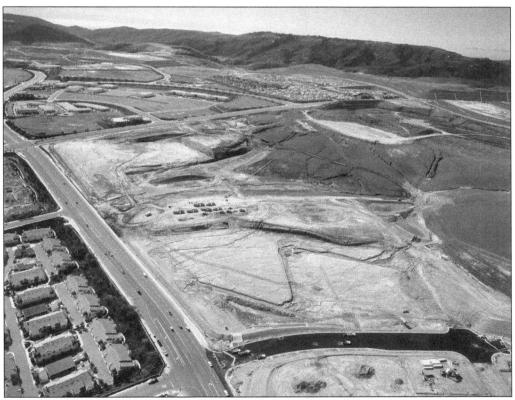

Aliso Viejo's development plan included approximately 900 acres for business use, including retail, offices, warehouses, light manufacturing, and assembly. With the exception of several retail centers located on the periphery of the community, most of these uses were concentrated in the central core area of the community. This 1995 photograph shows grading progress on the Town Center, with Aliso Creek Road on the left. (Courtesy of Aerial Eye, Inc.)

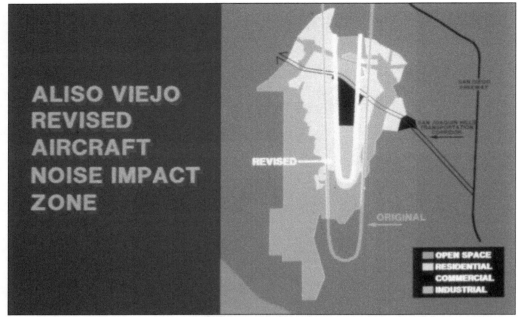

Aliso Viejo's urban core area boundary was dictated by the noise zone caused by jet aircraft during their landing approach into the El Toro Marine Corps Air Station. Pacific Park opened in 1985 and offered rough graded lots in areas known as terraces. Mission Viejo Company offered lots for sale to developers for selected products and to users for their own business facilities.

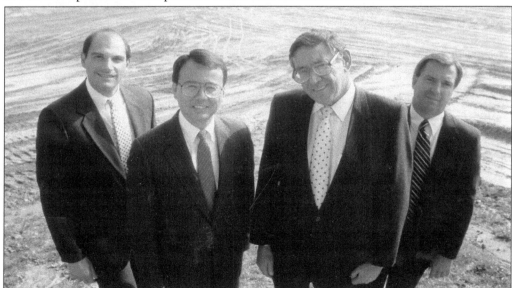

In 1984, Mission Viejo Business Properties began the grading of Pacific Park, a 900-acre business, corporate, and research park that occupied most of the central core of the new community. Heading up this division of Mission Viejo Company was Jack Raub, and sales and marketing was the responsibility of Bob Bunyan. The first exclusive sales brokers were Jerry Cole and Augie Napolitano from CB Commercial Real Estate. These men are gathered in this photograph and are, from left to right, Napolitano, Bunyan, Raub, and Cole.

To counter the locational challenge, extensive efforts were made by Mission Viejo Business Properties to educate real estate brokers and business owners about the attractiveness of Aliso Viejo as a place to do business. In January 1986, the opening of Pacific Park was celebrated with over 300 brokers, developers, architects, business owners, and the media at a luncheon held on the property. (Courtesy of Tom J. Carroll.)

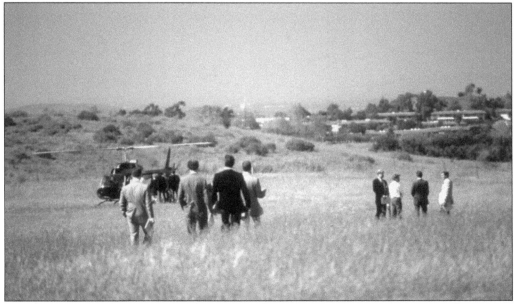

In order to expose the property and its surrounding amenities to as many interested parties as possible, a fleet of three helicopters flew passengers from a helicopter pad next to the luncheon tent. The 10-minute flight circled Aliso Viejo through Wood Canyon, over Laguna Niguel Regional Park, up La Paz Road, over Leisure World, and back to the landing zone in what is now the Aliso Viejo County Club clubhouse area. (Courtesy of Tom J. Carroll.)

During the initial marketing period for Pacific Park, from 1985 to 1987, helicopters were used extensively to show prospective buyers and brokers available property. Roads into the central and southerly parts of Aliso Viejo did not exist, and site tours over the property's bumpy, dusty roads were not always an effective selling technique. Helicopters would land and pick up passengers on a special pad built on what is now the parking lot of the Aliso Viejo Middle School. (Courtesy of Tom J. Carroll.)

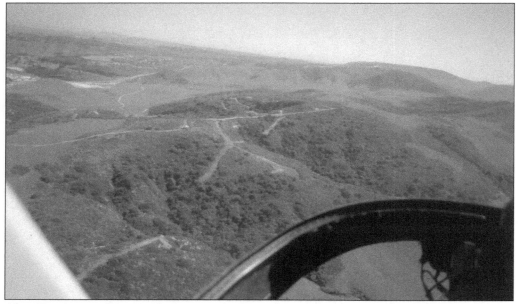

Aliso Viejo's rugged terrain also presented spectacular views and vistas. The property was graded into various terraces, or pads, wherein homes, businesses, and community facilities were built. This photograph also includes trails cut into the hills to provide access for surveyors and technicians evaluating soil conditions and potential fossil or native artifact deposits during the early years of the community's development. (Courtesy of Tom J. Carroll.)

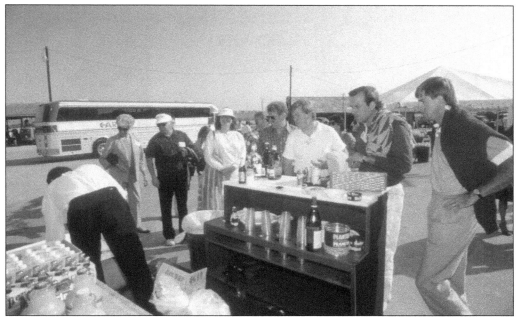

Aliso Viejo's business properties were also marketed by using the ranch headquarters to host prospect meetings, broker bus tours, and informational events. Broker tours were very popular and allowed Mission Viejo Business Properties to expose available land and the developing Aliso Viejo community to several hundred sales agents in a single day. (Courtesy of Tom Carroll.)

The ranch headquarters barn served as an exhibit center for many buyer and broker visits. Large-scale aerial photographs of Aliso Viejo and its surrounding communities, as well as exhibits showing available properties within the community, provided essential information for the marketing of Pacific Park and Aliso Viejo. Rough graded lots ranged in size from one acre to forty acres.

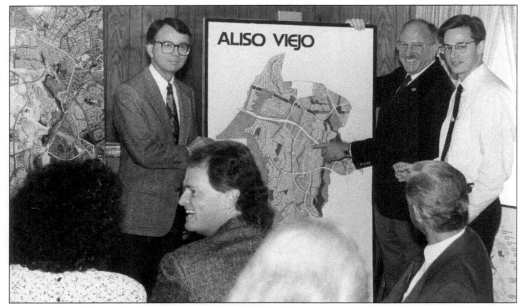

Ranch headquarters were often used to conduct periodic reviews of Aliso Viejo development plans with interest groups within the community. Periodic briefings were held to allow community leaders, residents, and businesses to learn of new developments and provide input to Mission Viejo Company. This 1991 photograph shows Bob Bunyan (left) and Rich Watson, a planner with Jack G. Raub Company, providing a briefing to the Pacific Park Alliance.

The ranch headquarters served as a site for many social, political, and business events. Political fundraisers, Mission Viejo Company anniversary parties, chamber of commerce mixers, and broker tour stops were just some of the events hosted at the ranch. The barn and paved area in front of it served primarily as the location for table seating and music. (Courtesy of Tom Carroll.)

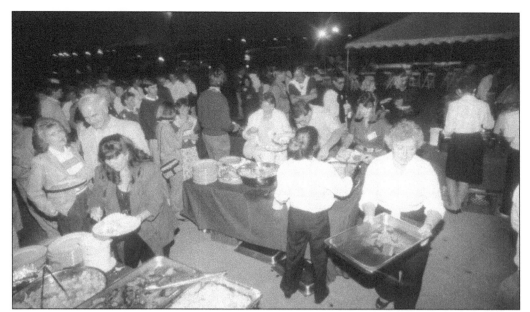

With hay strewn throughout on the floor, a sound system, and flood lighting, the barn was a favorite location for many events. The venue was often used for political candidates' forums and community events hosted by the South Orange County Chamber of Commerce. In this photograph, attendees enjoy a ranch specialty, tri-tip sirloin, which was broiled on the ranch's old-time barbeque grill. (Courtesy of Tom Carroll.)

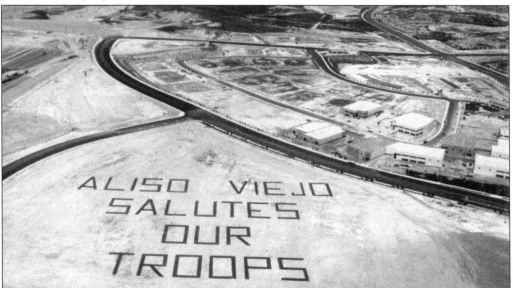

During the Gulf War, many returning troops were flown back home through El Toro Marine Corp Air Station. As a way of recognizing these men and women, Mission Viejo Company constructed a message on what is now property owned by Temple Beth El, Capistrano Unified School District, and the United States Postal Service. The sign was constructed out of rolls of black Visqueen plastic, which was staked to the soil and sized to be read by troops flying in the landing approach to El Toro.

The northern part of Aliso Viejo Pacific Park was made up of four terraces, each with a loop street named after a historic ship. The loop street for Terrace A is Argonaut, Terrace B is Brookline, Terrace C is Columbia, and Terrace D is Discovery. In 1997, when Fluor Corporation bought all of Terrace D for its new corporate headquarters, Discovery Street was demolished. This 1999 photograph shows Terrace D being graded. Note the alignment of the toll road to the right.

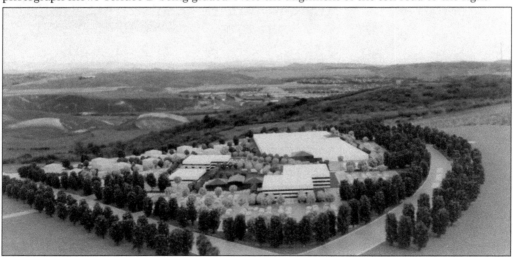

Following the opening of Pacific Park, numerous companies and organizations considered Aliso Viejo for their headquarters or regional offices, and some located in the community. In 1987, Baxter Healthcare, a major medical device company, considered building a 150,000-square-foot state-of-the-art heart valve facility in the community; it is depicted in this model superimposed on the site. Computer-generated photograph simulations had not yet been invented. This site is now occupied by Temple Beth El and Capistrano Unified School District.

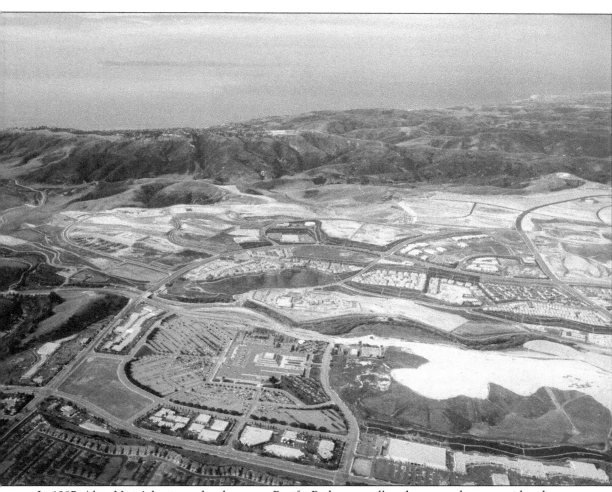

In 1987, Aliso Viejo's business development, Pacific Park, was well underway and was considered by General Motors for relocation of its advanced-concept design studio, which was then located in Calabasas, California. The "black box" building was to be located on a parcel now occupied by Soka University, seen in the upper left of this photograph. The facility would house GM designers who were planning vehicles that would appear five years in the future and beyond. GM decided to keep its designers in the Calabasas area, closer to the environment and lifestyle preferred by its young employees. Many vehicle manufacturers, such as Ford, Toyota, and GM, have set up concept-vehicle operations in Orange County. Aliso Viejo was considered by several other companies looking to build facilities requiring the highest level of security. (Courtesy of Aerial Eye, Inc.)

In 1984, George Allen, coach of the Los Angeles Rams, promoted the relocation of the US Olympic team to Aliso Viejo at the south end of the community, near the entrance to Wood Canyon Regional Park (in the lower center of this photograph). Allen was successful in obtaining backing and the approval of the United States Olympic Committee, and the project neared final approvals. Unfortunately, Allen met an untimely death and the project supporters, without Allen's drive, decided to drop the project. (Courtesy of Aerial Eye, Inc.)

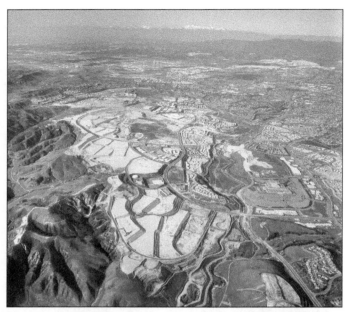

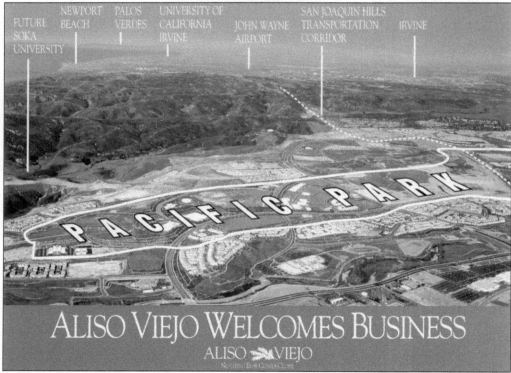

In 1987, Pacific Park was one of four major business parks with land for sale in South Orange County. The leading park was Irvine Company's Spectrum at the intersection of Interstate 5 and Interstate 405. Other competitive projects were Foothill Ranch Business Park and Rancho Santa Margarita Business Park. This period was extremely active, and all four business parks experienced dramatic growth.

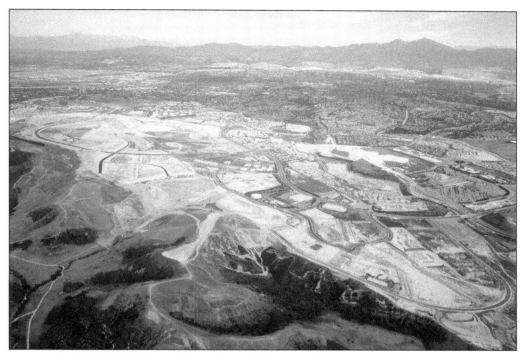

One disadvantage possessed by Pacific Park was that it was under the flight path for Marine Corp fighters, freighters, and bombers landing at El Toro Marine Corp Air Station, seen at the top of this 1992 photograph. Fighter jets, especially F-4 Phantoms, were like high-performance drag-racing cars with no mufflers, and they generated extremely high noise levels on approach. In 1999, however, the federal government closed El Toro and the Marine squadrons moved their operations to Miramar, near San Diego. (Courtesy of Aerial Eye, Inc.)

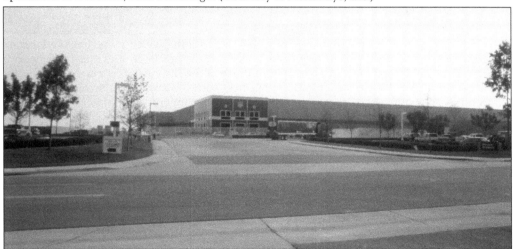

In 1988, United Parcel Service (UPS) purchased 36 acres for its new delivery distribution center in Aliso Viejo. It was one of the largest land sales in Pacific Park and one of the largest sales in the region up to that time. Today, 10 acres of the property remain for expansion. When Pacific Park opened, land that was fully graded and entitled for the designated use was priced at around $8 to $9 per square foot. Today, land prices are more in the range of $30 per square foot.

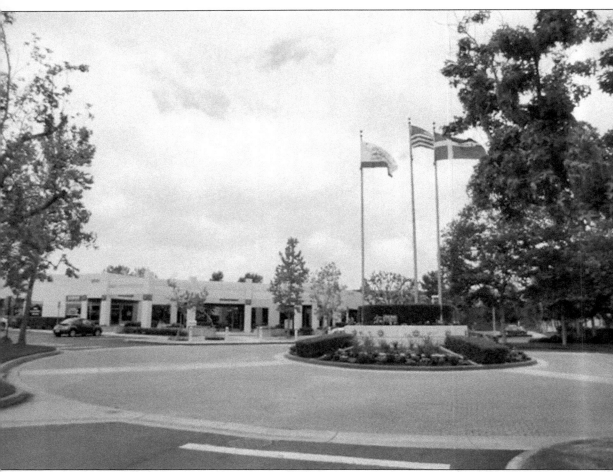

Mission Viejo Company adopted a strategy of selling land to both developers and users for business facilities. Speculative development projects provided a variety of space sizes and combinations of office, retail, and warehouse areas. In 1990, a group of Swedish investors purchased 12 acres in the center of Aliso Viejo for a multi-use business park to serve the growing needs of the burgeoning community. At that time, the unincorporated community had approximately 16,000 people and was growing quickly. The need for retail services, offices, and office/warehouse space led to the development of several new business projects, including Pacific Park Plaza. Today, the 127,000-square-foot project includes a wide variety of tenants.

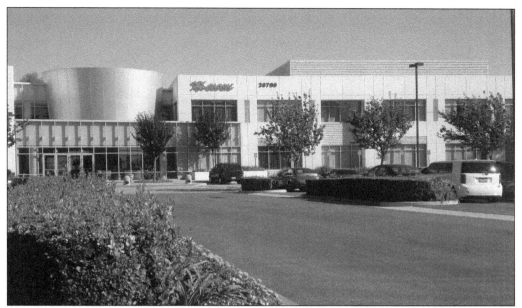

Since the opening of Pacific Park in 1985, a number of firms have located their corporate headquarters in Aliso Viejo. QLogic Corporation is a leading provider of data, server, and storage networking infrastructure and purchased its 15-acre site and buildings in Summit South from Parker Properties. QLogic has three campus buildings and an expansion parcel for a future building.

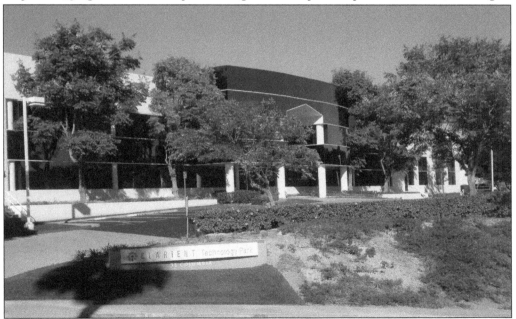

Clarient is a leader in comprehensive cancer diagnostics laboratory services. Clarient's facility, previously a carpet manufacturing plant, is an example of the evolution of land uses in Aliso Viejo. Most early businesses were primarily industrial in character, frequently assembling or distributing a lower value-added product. Today, more of these office/warehouse and manufacturing facilities house high-tech businesses that include clean rooms, laboratory space, and research facilities.

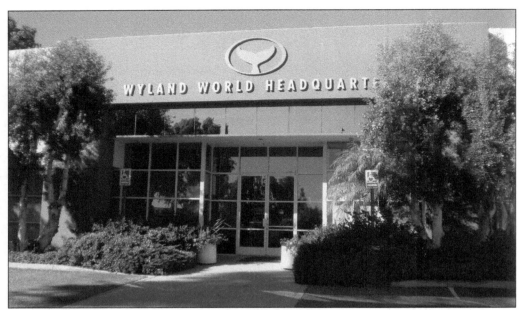

Aliso Viejo is home to Wyland Industries, a firm supporting marine resource conservation. Best known for his large whale murals painted on buildings and walls around the world, Wyland is an accomplished painter, sculptor, photographer, and diver.

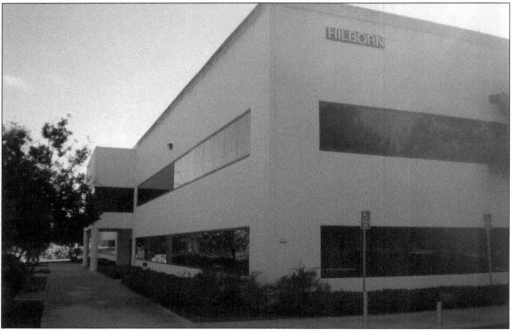

Aliso Viejo is a popular location for small and medium-size businesses whose owners or executives live in the South Orange County area. In 1995, Hilborn Fuel Injection purchased a parcel for its headquarters adjacent to the UPS facility in Aliso Viejo. Stu Hilborn is a legend in racing circles for his fuel injection systems. Hilborn's revolutionary fuel injector system was introduced to Indy racing cars in the late 1940s and led to decisive victories for the teams using his system.

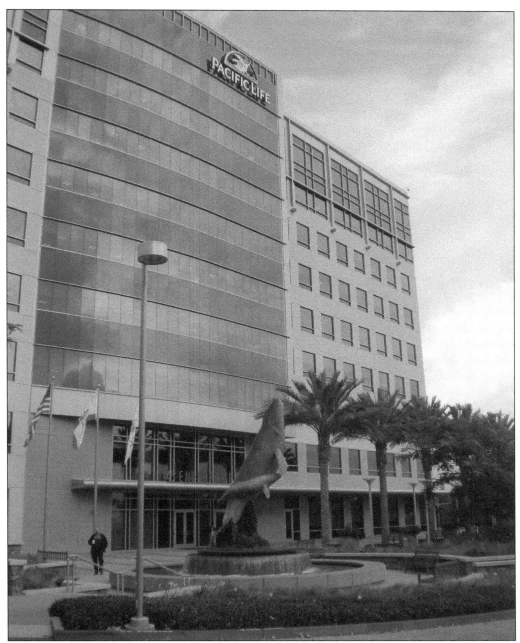

In 2008, Pacific Life Insurance established a major office facility in the Summit Office Campus with the construction of this 247,000-square-foot, nine-story office building next to the San Joaquin Toll Road. The facility became the first nine-story building in Aliso Viejo and is the tallest structure in the community. It was designed by the architectural firm of McLarand, Vasquez, Emsiak and features the company's trademark breeching whale sculpture at the entrance to the building. While its executive headquarters still remain in Newport Beach, the majority of the company's 1,000 employees work out of this office. Pacific Life offers a variety of financial products and services, including insurance, annuities, and mutual funds.

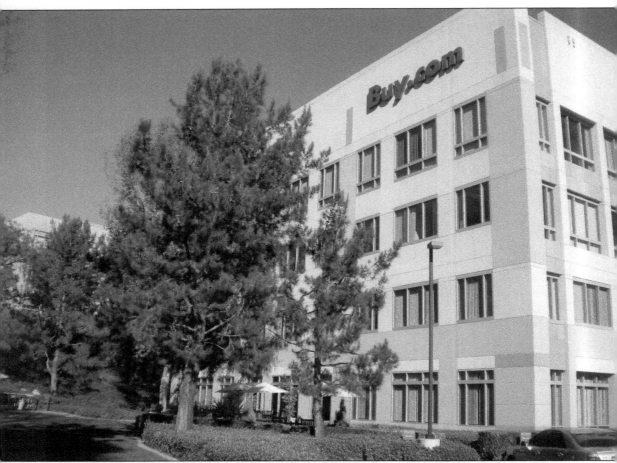

Buy.com, a major online retailer, was started in 1997 and located in the Summit Office Campus next to the San Joaquin Toll Road. Buy.com occupies a competitive position next to Amazon. com in the growing world of online retail sales. The founder of Buy.com represents a number of corporate owners and executives who located their firms in Aliso Viejo in order to be close to their personal residences in the South County and South Coast area. Businesses such as Buy. com have found an abundant and qualified workforce within Aliso Viejo and the surrounding South Orange County area

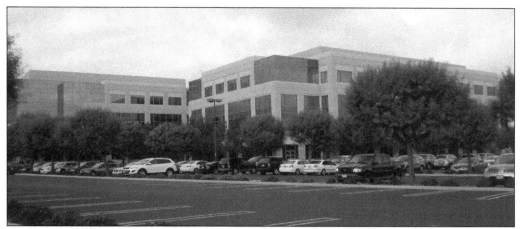

In 1998, Fluor Daniel Corporation made a decision to sell its headquarters in Irvine. After evaluating multiple locations, Fluor chose Aliso Viejo for its new headquarters. Fluor purchased the 20-acre Terrace D site for its engineering and construction operations and a three-acre site in the Summit Office Campus for its executive and administrative functions.

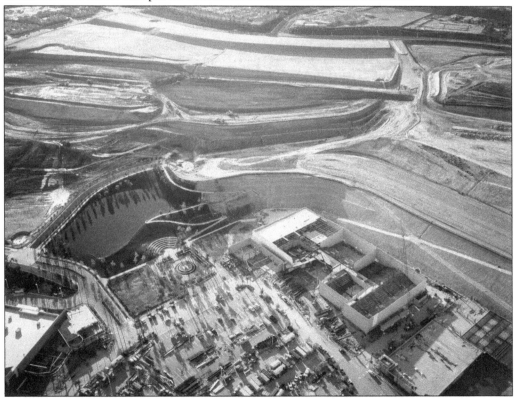

In 1993, Mission Viejo Company began the development of the Aliso Viejo Town Center, a 250-acre commercial retail project within the heart of the community. This "downtown" for Aliso Viejo would feature dining, entertainment, shops, and services, all within a short distance of housing and employment centers. In this photograph, the new Edward's movie theater is under construction, adjacent to Grand Park on the left.

In 1994, grading for the Aliso Viejo Town Center was completed, and the first parcel was sold to Hughes grocery chain. Mission Viejo Company subsequently planned for the remaining acreage in the Town Center, completed the grading of parcels, and instituted its own architectural and design requirements. Visitors today may notice design and material differences between the early southern portion of the Town Center and the northern portion.

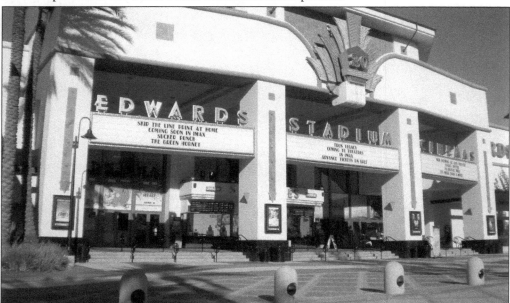

In the 1980s, the Edwards Theater chain was establishing its dominance in the Orange County market and designing its new cinemas with multiple screens and new features. Edwards initially lost the opportunity to locate in the Town Center when a competing theater chain entered into a purchase and sale agreement with Mission Viejo Company. However, when that chain balked at closing on time, Edwards was given a second opportunity and purchased the site.

The design of the Aliso Viejo Town Center was influenced by Mission Viejo Company executive vice president Steve Delson and his design team. Delson envisioned a retail environment with scale, wherein visitors and shoppers would relate easily to both large retail buildings and small shops. A version of the traditional downtown was introduced, with retailers facing the street. Storefront parking and traditional storefront sidewalks lend to the personal scale of this shopping experience. The location and design of the Town Center proved popular with large and small retailers. Parcel sales and leases during the mid-1990s were brisk. Today, the center is a major focus of shopping, dining, and entertainment within the community.

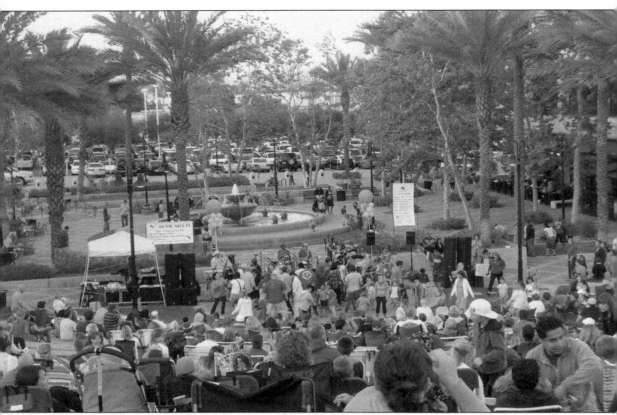

A major feature of the Aliso Viejo Town Center is the nine-acre Grand Park, a landscaped open area designed for community events and activities. The focal point of the park is its large fountain and plaza area, offering enjoyable resting areas for reading, relaxing, or for entertaining young children. Grand Park is often used for community events such as the annual Snow Fest and concerts. The fountain and plaza area was the location for the inauguration ceremony when the city was incorporated in 2001. Some of Grand Park's features include the fountain, park area, and surrounding common areas with piped music throughout the complex. All of the areas are well lit for nighttime activity and safety. Today, Grand Park and the Town Center enjoy enthusiastic use by residents and visitors well into the evening hours.

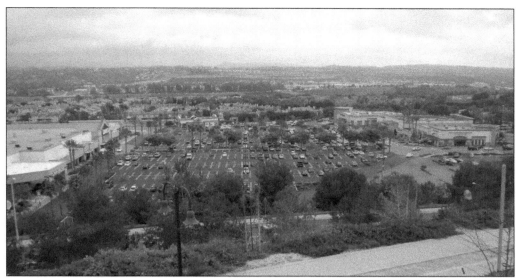

In 1993, the 25-acre parcel at Aliso Creek Road and the San Joaquin Toll Road was sold to the Kmart Corporation for a new Super Kmart retail center. The store was closed in 2003 when Kmart Corporation reorganized. The property was purchased by a private development group. The Super Kmart became a Lowe's home improvement center, and the residual part of the building became a Michael's craft supply outlet.

On the perimeter of the site, the old Applebee's gave way to Trader Joe's, Panera Bread, Walgreens, and inline shops. A new phase of shops, stores, and restaurants is planned for the western edge of the property and includes proposed condominiums. The Commons is an example of the change and evolution of property within Aliso Viejo as market area demographics, business conditions, and consumer tastes constantly change.

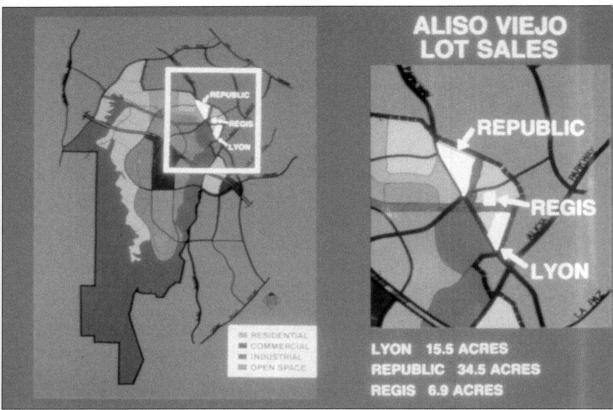

The development strategy for Aliso Viejo was to prepare parcels for sale to homebuilders for single family and multifamily projects and to commercial and industrial developers for retail, office, warehouse, and light manufacturing purposes. In addition, parcels would be reserved for users for their own buildings and for community and institutional uses, such as schools, religious centers, and public facilities. Some of the first parcels to be sold were in the northeast section of the community, where existing infrastructure could be utilized, thereby reducing construction costs. William Lyon Homes, Regis, and Republic Homes were some of the early pioneers. These subdivisions—Indian Creek, Indian Hill, and Indian Trail—were annexed into Laguna Hills when Aliso Viejo was incorporated.

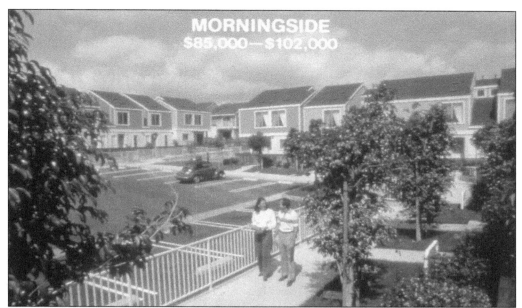

In October 1982, the first homes in Aliso Viejo were sold in the Morningside condominium development. Priced under $100,000, these homes were located along Pacific Park Drive and Alicia Parkway, convenient to shopping, schools, and arterials and freeways. Despite a downturned economy, Morningside homes sold well and signaled the entry of Aliso Viejo into the south Orange County housing market.

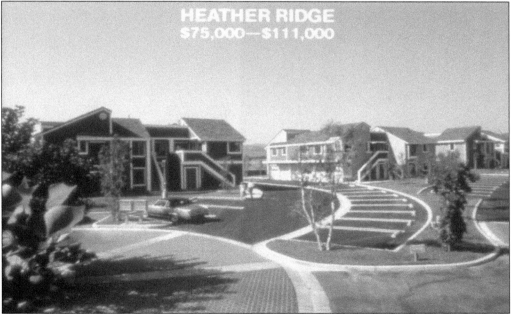

Following the opening of Morningside, the Heather Ridge townhomes opened in an adjacent tract, offering attached housing in the $75,000 to $111,000 range. Both of these projects reflected Mission Viejo Company's business strategy of providing higher-density housing in the initial phases of development to appeal to a younger market desiring more affordability.

One of the few duplex projects in Aliso Viejo is Eagle Pointe by Brock Homes. In the early 1990s, 83 units were offered for sale. This was an example of early housing products intentionally designed for higher density. Many of these projects had amenities including views, neighboring parks, or community swimming pools.

While Mission Viejo Company initially acted as the sole residential developer in Aliso Viejo, additional outside developers, such as Republic Homes and the William Lyon Company, were invited to buy parcels to widen the community product offerings. Heading up the residential sale department was John Franklin, who, along with his assistant Greg Currens, sold most of the land for housing use.

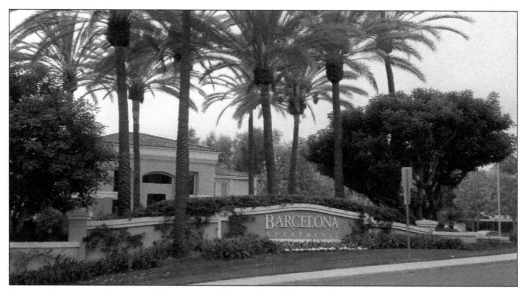

Apartments served to provide inexpensive and readily available housing for young and old, and Aliso Viejo possessed a large selection of high-quality and well-located projects, all located within 1.5 miles from shopping and services in the Pacific Park business center. The Barcelona apartment complex is an example of the high-quality rental projects built in Aliso Viejo.

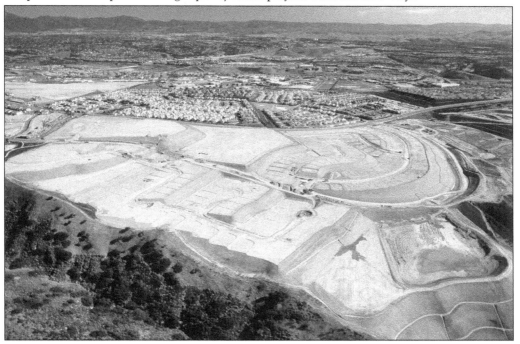

Mission Viejo Company introduced executive-style housing in the 1990s with its Westridge development on the western edge of Aliso Viejo. Grading operations began in the mid-1990s for half a dozen different projects. One of Shea Home's offerings in Westridge was Canyon View Estates, which had homes starting in the $700,000 range and offering three to seven bedrooms. (Courtesy of Aerial Eye, Inc.)

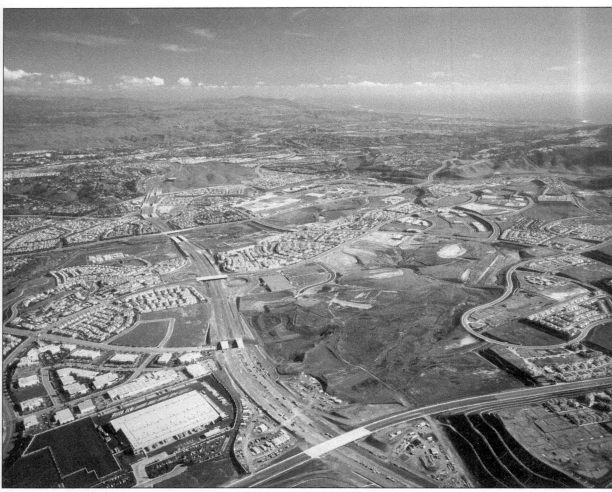

By 1991, Aliso Viejo ranked nationally in an Arthur Andersen survey as number one in new home sales for large master-planned communities. At the time, 53 different parcels totaling nearly 12,000 dwelling units had been sold or were in various phases of development. Within ten years of its first housing sales, Aliso Viejo had achieved over half of the planned 20,000 dwelling units approved for the community and was heading toward the completion of this capacity within the decade. However, an economic downturn starting in 1991 slowed development and sales of housing projects throughout the industry in Southern California. It would be several more years before the economy improved and sales began to pick up, leading to another cycle of explosive growth in Aliso Viejo.

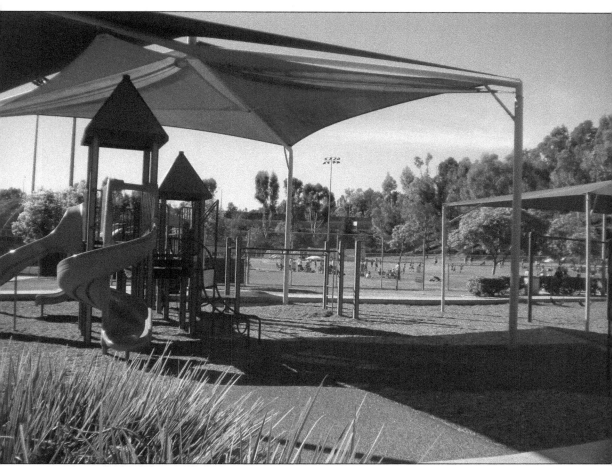

In 1979, Mission Viejo Company entered into a development agreement with the County of Orange wherein the county adopted amendments to the county general plan for the development of the Aliso Viejo Development Plan. A condition of the plan required that certain community facilities, such as parks and other common areas, be provided with no cost to the county. To achieve this objective, Mission Viejo Company established a master property owner's association in March 1982, the Aliso Viejo Community Association (AVCA), with the purpose of bringing civic betterments and social improvement as well as preserving architecture and the appearance of the community. AVCA is funded by all residential and business properties within the planned community.

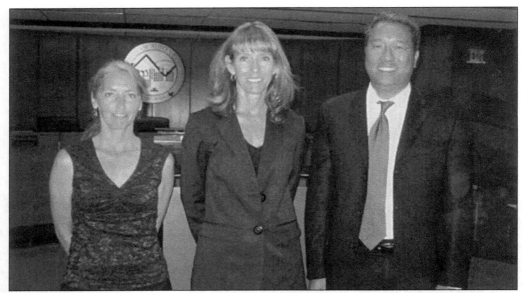

Every homeowner's association and business center in Aliso Viejo is a delegate district for AVCA, with each district electing their own delegate. A five-member board of directors is elected to serve staggered two-year terms. Elected in June 2010, these board members are, from left to right, Lisa Naegele, Katie Koster, and Ross Chun, the board's current president. Not pictured are board members Eric Sund and Jim Martin, previously elected. (Courtesy of the Aliso Viejo Community Association.)

AVCA has 107 different sub-associations within the community. Business is conducted at monthly meetings and typically includes issues dealing with the maintenance and management of local parks, landscape maintenance of major street slopes and parkway medians, architectural reviews, and community events. At this 2009 board meeting, awards are being presented to Aliso Viejo girls' softball teams. (Courtesy of Abrecht Photography.)

One of AVCA's services has been to plan and conduct various social and recreational activities throughout the year. One of the most popular events is the annual Independence Day celebration held at Grand Park in the Aliso Viejo Town Center. Approximately 6,000 people attend the Fourth of July community celebration, enjoying live entertainment, carnival games, arts and crafts, food and beverages, and a low-level fireworks show. (Courtesy of the Aliso Viejo Community Association.)

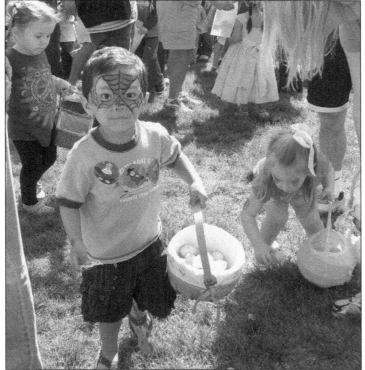

During the spring, the community celebrates the new season with an egg hunt and pancake breakfast along with games, face painting, and arts and crafts. Numerous restaurants, businesses, and nonprofit organizations participate in these events, which are held in various community parks run by AVCA. Here two Aliso Viejo youngsters demonstrate their egg hunting skills. (Courtesy of the Aliso Viejo Community Association.)

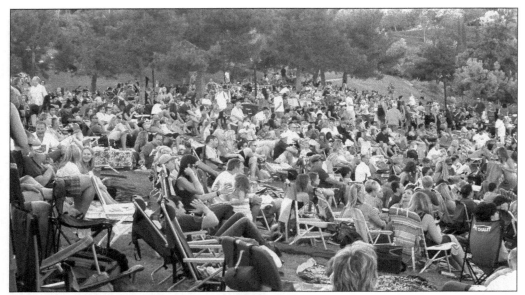

AVCA provides a summer concert series that includes five different bands selected by the association's events and recreation committee. About 1,000 people attend these concerts, which are held in Grand Park adjacent to the Aliso Viejo Town Center. The Aliso Viejo Events Committee, a volunteer committee of AVCA, coordinates these concerts. Residents enjoy dancing to one of the various bands and relaxing in chairs set up on the Grand Park turf. (Courtesy of the Aliso Viejo Community Association.)

AVCA is responsible for the preservation and improvement of the 22 parks that it owns in the community. These parks provide a wide variety of recreational opportunities. The largest park is the 90-acre Aliso Canyon Community Park at the very southern tip of Aliso Viejo.

Mission Viejo Company dedicated over 3,000 acres on the western portion of Aliso Viejo for the Aliso and Wood Canyon Regional Park, a major regional park owned and operated by the County of Orange. The park features scenic canyons, rock formations, oak and sycamore groves, fresh water marsh, and miles of hiking and biking trails. This 1997 photograph looks south, with Wood Canyon on the right. The Westridge community and Soka University are outlined in the center. (Courtesy of Aerial Eye, Inc.)

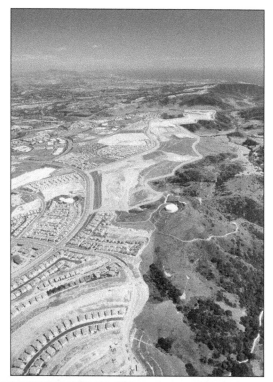

Wood Canyon also is home to a wetlands preservation project. Initially started by Mission Viejo Company as a wetlands mitigation area, the city continues to maintain this important environmental project. The access road to this area and Wood Canyon was planned to be the "trail to the sea," connecting access at Moulton Parkway to the parking lot at Aliso Creek Beach. Plans, studies, and initial approvals were obtained, but Mission Viejo Company was unable to obtain approval from a key property owner and the project was shelved.

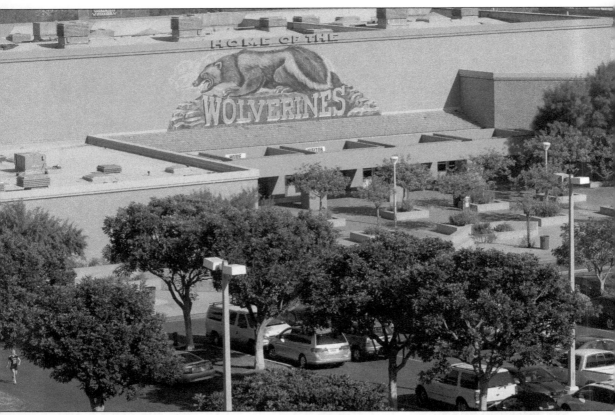

In 1993, Mission Viejo Company sold an 18-acre parcel to the Capistrano Unified School District for the community's public high school. The name Aliso Niguel High School was chosen to reflect the fact that most of the students were coming from Aliso Viejo and Laguna Niguel. Featuring fiber-optic technology, the school is one of the most sophisticated learning centers in the state, and in 1996, it was named a California Distinguished School, the newest high school (at the time only three years old) to ever earn that designation. Capistrano Unified School District went on to establish six additional middle and elementary schools in Aliso Viejo, as well as a district transportation center and future administrative office.

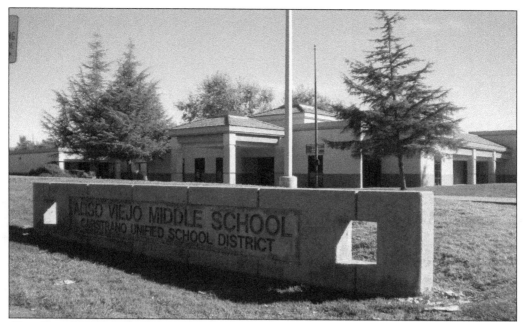

Aliso Viejo Middle School opened in November 1993 to serve sixth, seventh, and eighth grades. In 1996, the school was named a California Distinguished School and, like Aliso Niguel High School, was the newest middle school to ever earn this designation (three years old). The school is located directly opposite the Aliso Viejo Ranch headquarters on Park Avenue.

In December 1995, St. Mary's School purchased a 4.3-acre site in the southern end of Aliso Viejo for a new private school. The school would be one in a chain of highly esteemed private schools, including St. Margarets's in San Juan Capistrano, started by Father Ernest Sillers, an 85-year-old visionary Episcopal priest. St. Mary's is the only authorized preschool through eighth-grade International Baccalaureate World School in south Orange County. (Courtesy of St. Mary's School.)

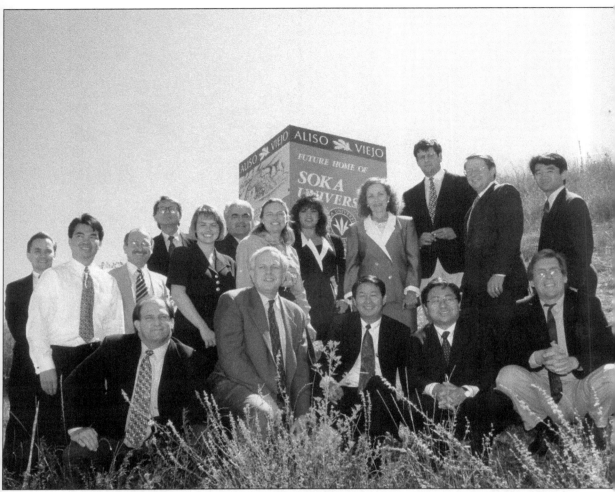

In June 1995, Soka University of America purchased 103 acres in the southerly portion of Aliso Viejo for a new liberal arts campus. The parcel, known as Planning Area 4.1, was originally planned for nearly 400 luxury single-family residential units with dramatic views of Wood Canyon. The university initially focused on a large parcel it owned in Calabasas, but redirected its preferences to Aliso Viejo after visiting the site. This photo shows many of the individuals involved in the site acquisition. In the first row, from left to right are John Franklin, vice president with Mission Viejo Company; Steve Delson, executive vice president with Mission Viejo Company; Shinji Ishibashi, with Summit Architects; Motoki Ogawa, vice president of administration with Soka's Calabasas campus; and Steve Davis, with Summit Architects. Soka University's mission is to foster global citizens committed to living a contributive life.

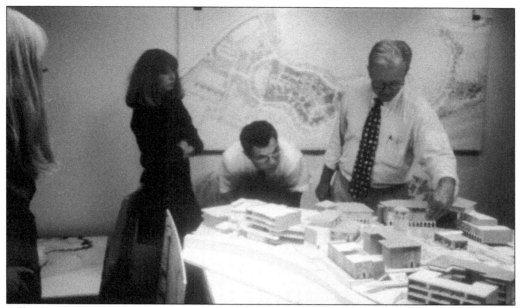

Following the purchase of the property, Soka's consultants began planning the layout of classrooms, dormitories, sports fields, and other support facilities. The goal of the university was to adopt "warm" architecture that would be timeless and to use high-quality materials that would withstand future wear and tear. About 2,800 tons of travertine stone were used in campus buildings, the same Italian stone used to build the Colosseum in Rome. (Courtesy of Soka University of America.)

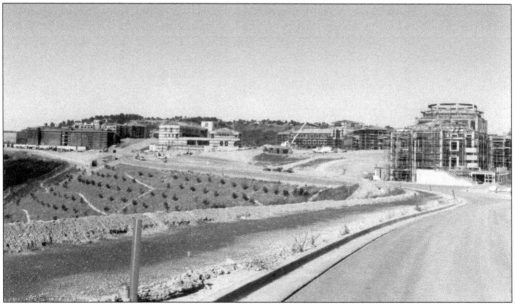

In 1999, construction was well underway on Founder's Hall (on the right), Ikeda Library (in the middle), and the student center and several dormitories (on the left). In all, the university has over 800,000 square feet of buildings. Campus designers have clustered the academic buildings, such as classrooms, the library, and the student center, in the center of the campus, with the less community-oriented buildings on the perimeter. (Courtesy of Soka University of America.)

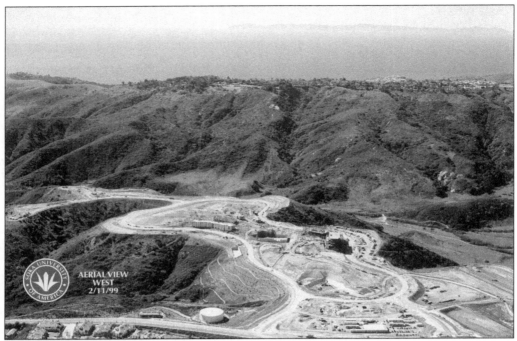

The 103-acre campus is situated on the top of a large peninsular parcel that was created by grading the top portion of individual hill tops. Circulation is provided by a loop road, University Circle, which is located on the periphery of the main campus. In this 1999 photograph, Aliso and Wood Canyon's Wilderness Park is visible in the middle of the photograph, and Laguna Beach, the Pacific Ocean, and Santa Catalina Island are visible in the upper portion. (Courtesy of Soka University of America.)

In its first year, Soka University welcomed 120 students. Charter students at Soka experienced firsthand the construction and completion of various buildings on the campus. The university students come from many different countries and backgrounds. (Courtesy of Soka University of America.)

On May 3, 2001, Soka University dedicated its campus. Four-year degrees were offered in liberal arts with concentrations in humanities, social and behavioral science, international studies, and environmental studies. All students are required to complete a study abroad program in their junior year as part of their learning experience. (Courtesy of Soka University of America.)

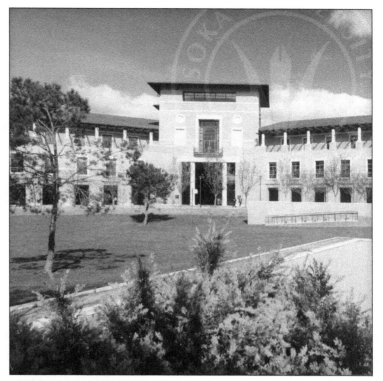

On June 3, 2000, university president Daniel Habuki was joined by Fifth District Supervisor Tom Wilson in celebrating the White House Millennium Trails Initiative. The university is actively involved with Aliso Viejo and the surrounding communities, often hosting meetings, conferences, and other events, such as the Jazz Monster concert series and International Festival. (Courtesy of Soka University of America.)

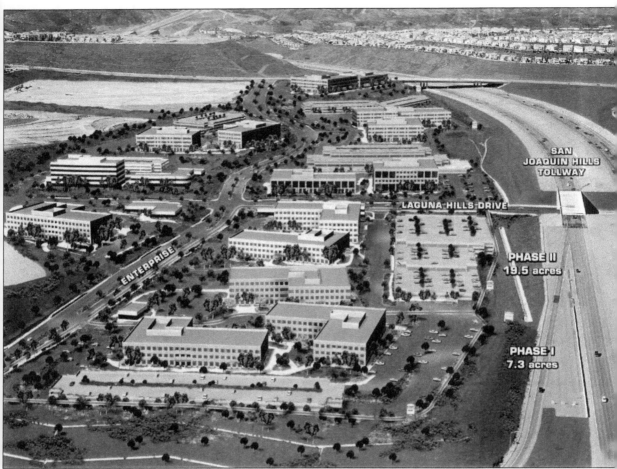

In December 1996, Parker Properties purchased 7.3 acres in a phased land sale that would eventually total 63 acres of Class A office buildings. Founded by John Parker, Parker Properties specialized in building attractive workplace environments in excellent locations. The Summit Office Campus was planned for 1.8 million square feet of mid- and high-rise office buildings adjacent to the San Joaquin Hills Tollway. Phase one of the Summit included two buildings and a parking structure that were fully leased on completion in 1998. Parker would go on to develop succeeding phases and attract such well-known companies as Pacific Life Insurance, Lennar Homes, and Bausch & Lomb. (Courtesy of Parker Properties.)

By the time of city incorporation in 2001, Parker Properties was the largest independent developer within Aliso Viejo, with 1.5 million square feet of office space in several locations. Ownership and management of the development company resides with several family members. On the right is founder John Parker and his son Russ Parker, his partner in the firm. (Courtesy of Parker Properties.)

The Summit Office Campus includes seven phases, with all phases developed except phase seven, adjacent to the Pacific Life building and the parking structure. Currently, 1.2 million square feet have been built. Project features include fiber-optic cabling, landscaped outdoor meeting areas with water elements, and large sheltered plaza areas. (Courtesy of Parker Properties.)

The latest phase of Summit features two four-story office buildings totaling 260,000 square feet. Unique features of this phase include a 50-foot waterfall attached to the parking structure serving these buildings and multiple outdoor landscaped work areas. The waterfall provides a strong design relief to the large 1,500-car parking structure. (Courtesy of Parker Properties.)

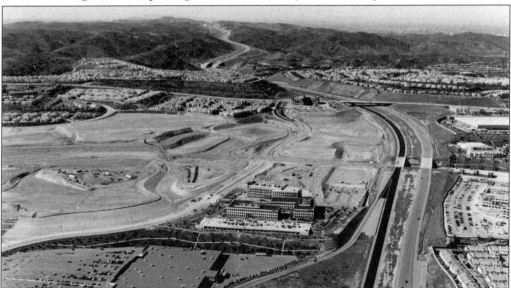

Grading on the summit began during the construction of the San Joaquin Hills Transportation Corridor (State Route 73). The 15-mile toll road ran through three miles of Aliso Viejo, providing access and exit points at four interchanges across the community. The road was designed to relieve congestion on Interstates 5 and 405, as well as Pacific Coast Highway. A future high-occupancy vehicle access point is designed into the Aliso Viejo Parkway underpass but has yet to be built. (Courtesy of Parker Properties.)

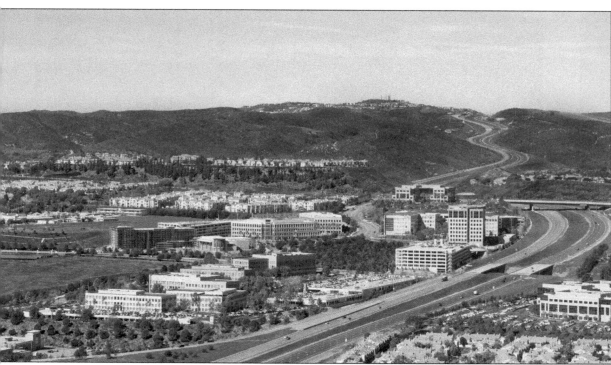

The San Joaquin Hills Transportation Corridor was originally planned to extend Pacific Coast Highway from MacArthur Boulevard through the hills of what is now Newport Coast. Through the combined efforts of the County of Orange, the City of Irvine, the Irvine Company, various surrounding cities, and Mission Viejo Company, the corridor was rerouted through a portion of southern Irvine, Aliso Viejo, Laguna Niguel, and Laguna Hills, eventually connecting to Interstate 5 south of Avery Parkway. Three miles of the road run through Aliso Viejo and were graded by Mission Viejo Company as part of a $50 million improvement commitment to the road. (Courtesy of Aerial Eye, Inc.)

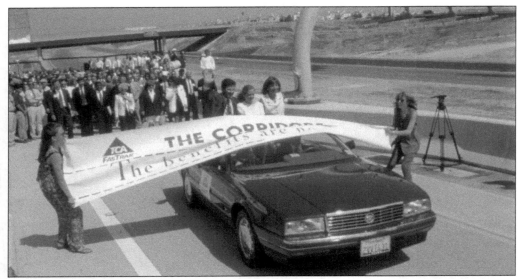

On November 21, 1996, the San Joaquin Hills Transportation Corridor, SR 73, officially opened to the public. Present at the event were elected and appointed officials from surrounding cities and dignitaries from other state and local agencies. Marian Bergeson, county supervisor representing the Fifth District, provided an opening speech at the ceremony. SR 73 was the first toll road in California to be financed with tax-exempt bonds on a stand-alone basis. (Courtesy of the Transportation Corridor Agencies.)

During the grading for the toll road, numerous fossils were discovered. Some examples included Megalodon sharks, giant mammoths, and duck-billed dinosaurs. The Transportation Corridor Agencies (TCA) worked with the Orange County Harbors, Beaches, and Parks Division and Cal State Fullerton to ensure that the fossils were properly prepared, documented, and stored. (Courtesy of the Transportation Corridor Agencies.)

Fossil exhibits are featured in the lobby of the TCA headquarters in Irvine, California. This fossil is a vertebra from a Baleen whale that was found during grading of the toll road through Aliso Viejo. Paleontologists and archaeologists monitored the grading and collected fossils that span 90 million years. In addition to prehistoric animal fossils, archaeologists discovered artifacts and other evidence of Native Americans who occupied this land thousands of years ago. (Courtesy of the Transportation Corridor Agencies.)

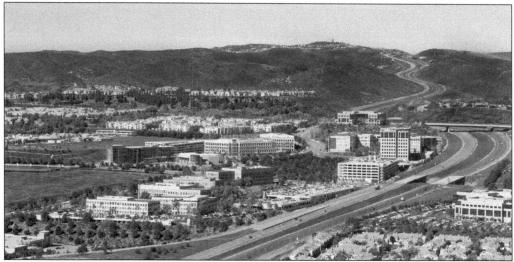

The 15-mile toll road through Aliso Viejo provides a direct connection to John Wayne Airport 11 miles away. The road cost approximately $800 million and was funded through tollway bonds and developer impact fees. The TCA, a joint powers authority formed in 1986, operates both the San Joaquin Hills Transportation Corridor and the Foothill Transportation Corridor. Each road has a separate agency and board of directors.

In 1997, Philip Morris sold all of the assets of Mission Viejo Company to Shea Homes for a reported $473 million. Shea Homes acquired significant land assets in the planned communities of Mission Viejo, Aliso Viejo, and Highlands Ranch in Denver, Colorado. It also acquired experienced professionals who had a management culture similar to that of Shea. J.F. Shea Company, the parent of Shea Homes, was founded in 1881 and went on to become one of the largest privately owned construction and development companies in the country.

Upon the closure of El Toro Air Base in 1999, the 65 CNEL noise zone over Aliso Viejo no longer prevented the development of residential housing. Shea Homes moved quickly to develop homes and business facilities in Aliso Viejo, including projects such as the 104-acre Glenwood at Aliso Viejo golf course–oriented community of attached and detached homes overlooking the Aliso Viejo Country Club. This development got underway in 2005. Plans call for 502 dwelling units and $20 million in community amenities. Glenwood's homes and common areas include some of the most attractive architectural features in the city.

In addition to for-sale housing, Shea was a major owner and developer of apartments. City Lights, a 750-unit luxury apartment project adjacent to Grand Park, featured an innovate design that placed parking within a multilevel structure in the center of the parcel and wrapped all of the housing units around the structure. This was less expensive than typical underground parking and made more efficient use of the surface area of the parcel.

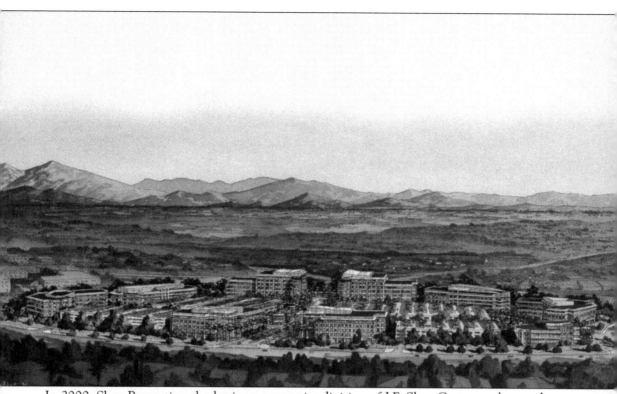

In 2000, Shea Properties, the business properties division of J.F. Shea Company, began the development of the 40-acre Vantis project in the heart of Aliso Viejo. The original design, depicted in this rendering, envisioned Vantis as the major employment center for the community, with seven Class A office buildings from three to eight stories, including multilevel parking structures totaling 1.5 million square feet. The dot-com recession of 2001 temporarily slowed development of Vantis. However, the first building was completed along with an initial parking structure. This five-story building was leased to Safeco Insurance, which became the first tenant company in Vantis. A three-story building was constructed next and serves as the headquarters office for that division.

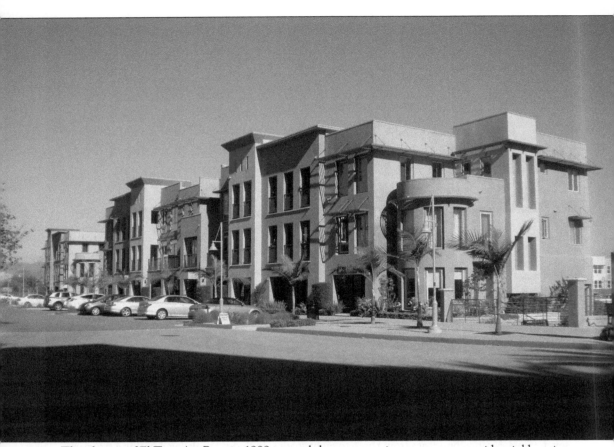

The closure of El Toro Air Base in 1999 created the opportunity to construct residential housing in Vantis. Shea Homes introduced several higher-density projects. Live-work units represented a new product that allowed business owners to operate small enterprises on the ground level while using the upper two levels as their residences. The product proved so popular that Shea Homes expanded its offerings to additional phases of the project. City Walk, in this photograph, introduces the urban lifestyle envisioned in the community's original master plan.

Four

CITYHOOD
ORANGE COUNTY'S 34TH CITY

On July 1, 2001, Aliso Viejo became the 34th city incorporated in Orange County. The inauguration ceremony was held in Grand Park and was attended by numerous state and local dignitaries. Aliso Viejo was incorporated as a general law city, with a council-manager system of government. The first city council included Carmen Vali, the city's first mayor, who is pictured in white in the center of this image. Surrounding her are, from left to right, Bill Phillips, Karl Warkomski, Cynthia Pickett, and Greg Ficke. The council members have staggered four-year terms. (Courtesy of the City of Aliso Viejo.)

The roots of cityhood started in early 1995 when the governmental affairs committee of the master association began efforts to incorporate Aliso Viejo as a city. The major motivation for this move was to transfer decision-making affecting Aliso Viejo from the County of Orange to locally elected representatives. This transfer of authority and responsibility would provide local control over municipal services and planning and approval of future development of the city. Two members of this committee, Carmen Vali and Cynthia Pickett, pictured here, were instrumental in pushing this effort forward. Incorporation was preceded by an extensive analysis of the feasibility of cityhood, including a fiscal analysis and approval by the Local Agency Formation Commission (LAFCO). (Courtesy of Ray de Leon.)

As a result of incorporation, Aliso Viejo gave up several pieces of land within the original community boundary to the City of Laguna Hills and annexed property from the City of Laguna Woods. The Indian Creek and Indian Hills residential projects on the east side of Moulton Parkway were annexed into Laguna Hills, while property on the western edge of Moulton parkway and adjacent to Aliso Viejo's golf course were added to Aliso Viejo. (Courtesy of the City of Aliso Viejo.)

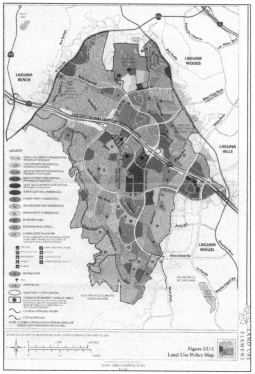

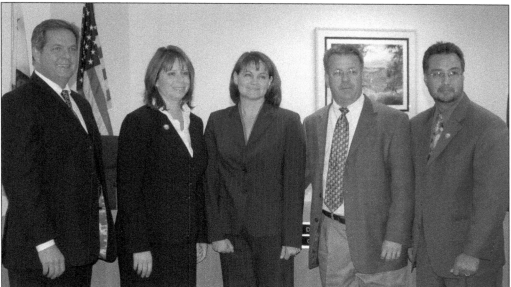

In 2007, charter councilmember Karl Warkomski moved from Aliso Viejo and was replaced by Don Garcia. All council members possessed years of experience with Aliso Viejo prior to cityhood. Pictured here are, from left to right, Greg Ficke, Carmen Cave, Cynthia Adams, Bill Phillips, and Don Garcia. Prior to incorporation, Cave and Phillips served on the AVAPC, tasked with reviewing new development projects and providing the County of Orange with recommendations. Ficke has served as a council member since incorporation. (Courtesy of Ray de Leon.)

Following incorporation, city leaders rented space in 12 Journey to serve as the official city hall. Eventually, the city purchased the building and remodeled the first floor to house staff and council chambers. In addition to the city manager, public works, and the planning and building departments, city hall also houses police services and community services. Many public gatherings are held in the city's modern council chambers, including city council hearings and planning commission meetings.

Beginning in 2002, the city began efforts to develop its general plan. California law requires that the city prepare a general plan to address issues related to future growth and development. In April 2004, the city council adopted the city's first plan. The document serves as a blueprint for what residents want the city to become over the next 20 years.

Aliso Viejo contracts for police and fire services from the Orange County Sheriff and Orange County Fire Authority. Aliso Viejo Police Services has offices in city hall as well as in the sheriff's substation directly across from city hall. Planning, building, public works, and other city departments are located in city hall. Pictured are, from left to right, John Whitman, public works director; Diane Arnett, public works assistant; Will Chen, building department assistant; and Jennifer Lowe, assistant planner.

Bill Woollett (center) held the distinction of being the first city manager for Aliso Viejo. Wollett also served as the chief executive officer for the TCA. In this 2008 photograph taken with Aliso Viejo councilmember Bill Phillips (left) and Laguna Hills councilmember Linda Lindholm (right), Woollett participates in the groundbreaking for a new off-ramp on the SR 73 toll road at the Glenwood interchange in Aliso Viejo. (Courtesy of Betty Jo Woollett.)

The Aliso Viejo Family Resource Center was added to the city's list of community facilities upon incorporation. Located in the Iglesia Park neighborhood that was originally part of the City of Laguna Woods, this center provides resources, programs, and activities to assist families and individuals in the area. The center is owned and operated by the City of Aliso Viejo.

In this picture, a young bicyclist is receiving safety instructions at one of the programs run by the Aliso Viejo Family Resource Center. The center provides afterschool activity programs for youth, English as a second language classes, homework programs, and information and assistance for family health. (Courtesy of Ray de Leon.)

Each June, the City of Aliso Viejo and the Aliso Viejo Community Foundation have conducted the Aliso Viejo Community Cup golf tournament to benefit community service organizations in the city. The perpetual trophy, shown in this picture, has a plaque with the name of the top-placed foursome and is displayed within the city council chambers at city hall until the next tournament. (Courtesy of the City of Aliso Viejo.)

James Littlejohn, on the right, executive director of the Boys & Girls Club of Capistrano Valley, joins city manager Mark Pulone to check in for the 2010 annual Aliso Viejo Community Cup. Since 2004, the tournament has been a fundraiser conducted by the Aliso Viejo Community Foundation along with the City of Aliso Viejo to fund community programs such as the Family Resource Center. (Courtesy of Ray de Leon.)

Many service groups within the city provide volunteers to staff the Community Cup. In this photograph, volunteer Margo Beauchamp, with Alison Viejo Police Services, helps guide players registering for the 2010 tournament. Events like this bring together residents and businesses within the city for worthwhile causes. (Courtesy of Ray de Leon.)

Community Cup chairman and city councilman Don Garcia presents awards to the winning tournament players at the June 2010 event. The beautiful Aliso Viejo Golf Club is the host course each year and provides an exciting round of golf for all. The tournament awards banquet is held in the city's new conference center adjacent to the clubhouse. (Courtesy of Ray de Leon.)

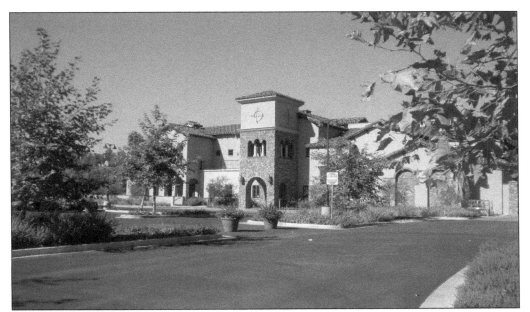

The Aliso Viejo Golf Club is an 18-hole, Jack Nicklaus–designed championship-length course built in 1998. The clubhouse opened in 2009 and is owned and operated by ClubCorp, a golf course owner/operator based in Dallas. The club offers private golf membership, but the course allows public play. The clubhouse has facilities for banquets, weddings and receptions, birthday parties, and other events.

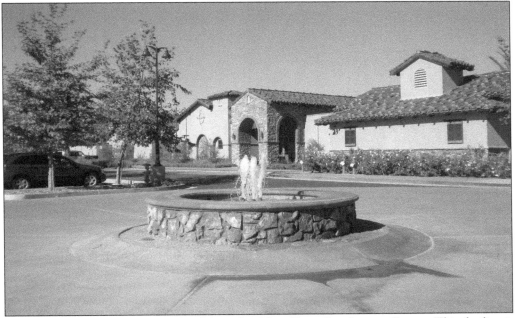

Adjacent to the Aliso Viejo Golf Club is the Aliso Viejo Conference Center. This facility is owned by the city and is available for meetings, conferences, wedding receptions, and other assembly type events of up to 250 people. The conference center often is the site for community meetings and events.

Next to the conference center, the city owns and operates the Aliso Viejo Aquatics Center. This facility includes a 25-meter lap pool, recreation pool, splash pad, and toddler wading pool. Visitors enjoy lap swimming, water aerobics, swim lessons, pool parties, and other activities from May through September. The center also offers lockers, a snack bar, cabanas, and a patio with an outdoor fireplace.

The city's annual Snow Fest is a popular event held at Grand Park that offers wintertime fun for thousands of children and their parents. Tons of snow are trucked into the park to provide a fast and exciting run down the park's steep slopes. This is one of numerous events conducted by the city in cooperation with the AVCA. (Courtesy of Ray de Leon.)

Another annual event within the city is the Founder's Day Fair, held each September at the Aliso Viejo Ranch. This country and old-timer event celebrates the history of Aliso Viejo, especially the past days of cattle raising, farming, and ranching. It also recognizes the history of the ranchland and surviving structures and the pioneers involved in developing the community. Here charter councilmember Karl Warkomski enjoys the festivities. (Courtesy of the City of Aliso Viejo.)

Each year, the city recognizes residents who have volunteered to serve in the community. In this 2009 photograph, then Mayor Phil Tsunoda and Councilmember Carmen Cave, on his left, recognize volunteers in the ceremony held at the conference center. This ceremony reflects the city's pride and gratitude to all of its citizens who serve the community. (Courtesy of Ray de Leon.)

Since incorporation in 2001, city leaders have adhered to the original master plan prepared by Mission Viejo Company. Some changes have occurred since adoption of the plan in 1979, such as the rezoning of the open space that is now a golf course, and the rezoning of the Vantis project and other portions of the urban core. These were a result of the closure of El Toro Air Base and the departure of military aircraft over Aliso Viejo. Additional improvements, such as these new street medians and monument pilasters, are examples of the city's efforts to beautify Aliso Viejo and emphasize its unique identity.

Another addition to the city has been the adoption of new city marker monuments in 2009. Located at strategic intersections, these monuments reflect the ranching heritage of the community. The stylized type is similar to the Aliso Viejo brand used in an earlier era to denote livestock belonging to the Aliso Viejo Company, a subsidiary of Mission Viejo Company.

Original Aliso Viejo monument signs were designed and located to delineate the boundaries of the new community, to identify projects, and to provide visitors and residents with location orientation. All of the new home-directional signs have been removed and only community-identification signs remain. The city eventually plans to replace these signs with more updated versions.

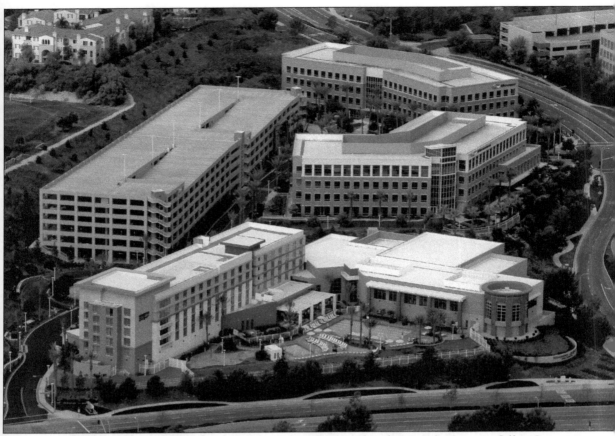

In July 2008, a 175-room Renaissance ClubSport opened its doors in the Summit Office Campus. This ultra-chic facility includes an extensive health and fitness center featuring a full gym, weight and exercise training, a swimming facility, a sauna, steam rooms, and a spa. The project, developed, owned, and operated by Leisure Sports, Inc., combines an upscale hotel with a fully equipped and staffed health facility. The hotel was originally operated by the Marriot hotel chain and the design featured a common lobby serving both the hotel guests and health club members and guests. (Courtesy of Leisure Sports, Inc.)

Renaissance ClubSport provides a full array of services for its members and guests. Meeting and conference rooms are available for business or social events. The ClubSport lobby includes access to the day spa, health facilities, a restaurant, a bar, an outdoor patio, and pool facilities. Leisure Sports, Inc. is based in Pleasanton, California, and owns similar facilities in other parts of the state. (Courtesy of Leisure Sports, Inc.)

During the 1980s, Mission Viejo Company studied the support for hotel lodging in Aliso Viejo. A full-service resort-type hotel was not considered feasible without a golf course or other destination amenity. However, by the mid-1990s, the buildup in population, area income, and the influx of larger employers provided a basis for considering a hotel and health club such as Renaissance Clubsport. (Courtesy of Parker Properties and Leisure Sports Inc.)

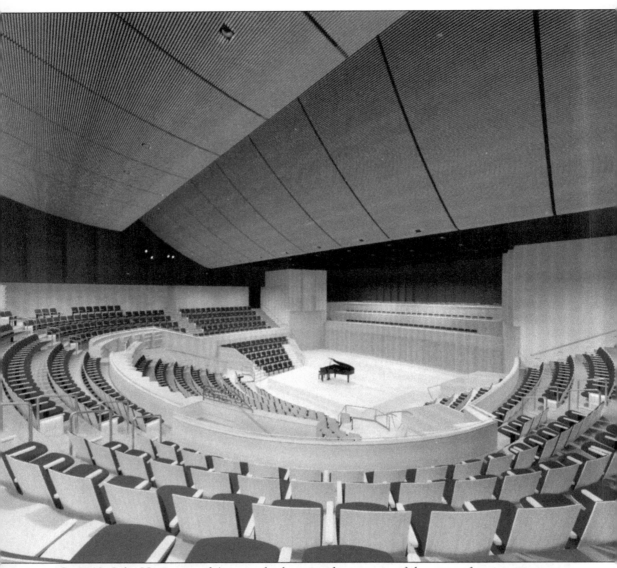

In 2009, Soka University of America broke ground on a state-of-the art performing arts center designed to hold concerts, lectures, theater and dance performances, and university-wide gatherings. The three-level center features a multipurpose theater that can be configured into a 960-seat concert venue, a 1,048-seat theater venue, or a 1,200-seat convocation venue. The facility features local community members, well-known guest artists and lecturers, and diverse international audiences. The world-renowned acoustician Yasuhisa Toyota of Nagata Acoustics, who designed the acoustic architecture for the Walt Disney Concert Hall, Mariinsky Hall in St. Petersburg, and the Helsinki Music Center Concert Hall in Finland, provided the acoustical design for the Soka Performing Arts Center. (Courtesy of Soka University of America.)

On November 11, 2009, dignitaries from Soka University, the City of Aliso Viejo, and the community gathered at the site of the new performing arts center to celebrate the placing of the final top beam on the building. The new facility was completed in October 2010 and was dedicated in May 2011 as part of the 10th anniversary celebration of the Aliso Viejo campus. (Courtesy of Soka University of America.)

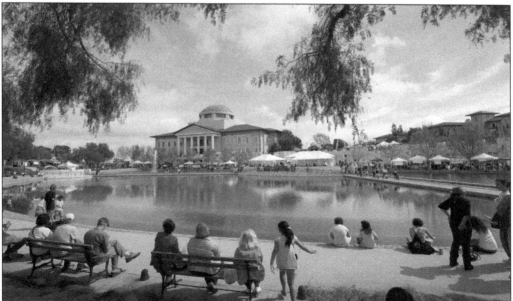

Each spring, Soka University celebrates its annual International Festival. The event features musicians, dancers, crafts, games, and activities, all with an international flavor. Nonprofit organizations participate in the event and find the venue popular for showcasing their work. This photograph shows exhibitors surrounding Peace Lake in front of Founders Hall. (Courtesy of Soka University of America.)

As Aliso Viejo heads toward its 10-year anniversary in 2011, it has nearly achieved full development in just a short 30-year time span. Since the first residents moved into the community in 1982, Aliso Viejo has become a fully functioning city with nearly 48,000 residents. Only a handful of undeveloped parcels remain, primarily for business uses. These include the 25-acre United States Postal Service (USPS) site; the 10-acre UPS expansion site, approximately 5 acres in Vantis and the Summit, and two 4-acre and one 1-acre parcels in Pacific Park II, south of the Aliso Viejo Town Center. Some additional land is also available for retail and residential development in the Aliso Viejo Commons retail center.

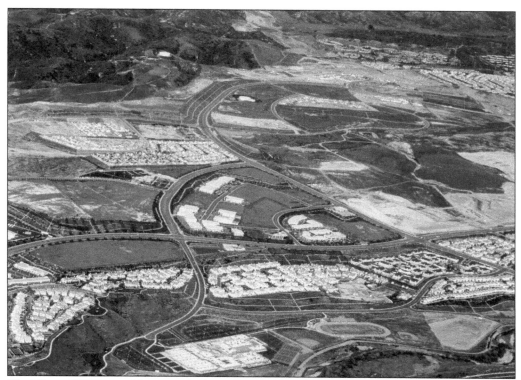

The 25-acre USPS parcel (at center left) is still undeveloped, even after being purchased by the postal service 20 years ago. It has been declared surplus and will be sold for eventual development. Due to the current economy, the property has remained vacant and unsold. (Courtesy of Aerial Eye, Inc.)

The 10-acre UPS site was originally purchased to provide expansion potential for this international package carrier. Zoned for business use, the property continues to be held by UPS. This site was one of the first industrial properties to be sold in Aliso Viejo, closing escrow in 1988.

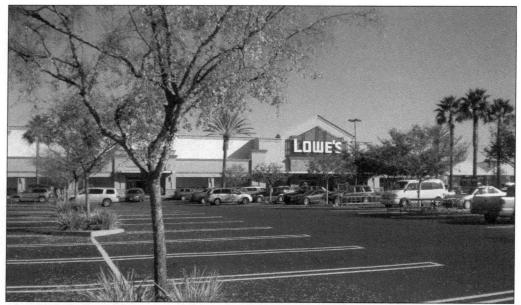

The Commons at Aliso Viejo is a 10-acre retail development on a parcel that once housed a 120,000-square-foot Super Kmart. In 2001, the property was sold, and private developers replaced the Kmart with a Lowe's home improvement center and Michaels craft store. Then existing peripheral tenants were moved out or relocated, resulting in a new grouping of retail shops, stores, and restaurants.

Currently, the Commons has completed phases one and two and was ready to begin phase three when the current economic recession slowed and then stopped all construction. Phase three included approximately 85,000 square feet of shops, stores, and restaurants, a community room, a sheriff's substation, up to 140 residential units, and a parking structure.

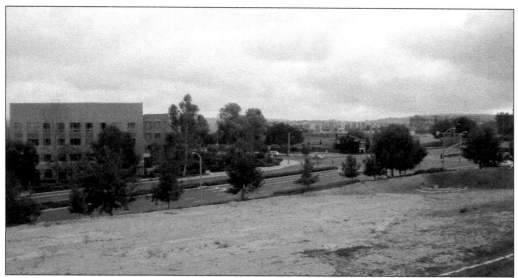

The 63-acre Summit Office Campus is nearly fully developed, with the exception of one remaining four-acre parcel adjacent to the Pacific Life Building and parking structure. Previously approved plans called for a high-rise Class A office building along with an adjacent parking structure. This parcel is owned by Parker Properties and when developed, will complete the Summit project.

Shea Homes and Shea Properties own the remaining five-acre Vantis parcel and expect to develop additional residential and office space on the site. Plans call for several different residential products, all higher-density attached units, as well as several midrise office buildings and a parking structure.

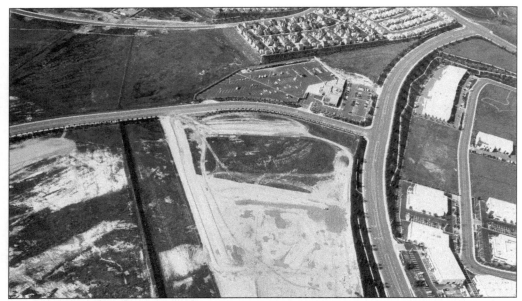

The Capistrano Unified School District purchased a four-acre parcel in 1991 to build a 40,000-square-foot administration building. The site, adjacent to the district's bus transportation yard, has been considered for senior housing. However, the economic recession has delayed disposition of the property. This 1996 photograph shows the bus yard being graded. The four-acre site is to the right of the new driveway being graded from Liberty Street at top center. (Courtesy Aerial Eye, Inc.)

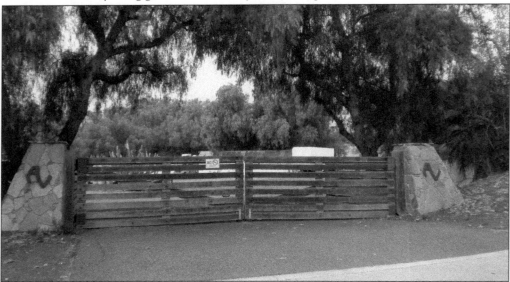

The city-owned seven-acre Aliso Viejo Ranch is also one of the last undeveloped properties in the city. Various city sponsored idea exchanges have been held over the years to obtain resident input on this historical property. A master plan has been developed by the city incorporating suggestions and ideas from residents. Restoration of the front gate and overhead sign are potential future projects. This parcel is all that remains of a bygone era when cattle roamed the land, automobiles were a novelty, and the nearest neighbor was miles away. (Courtesy of the Aliso Viejo Community Foundation.)

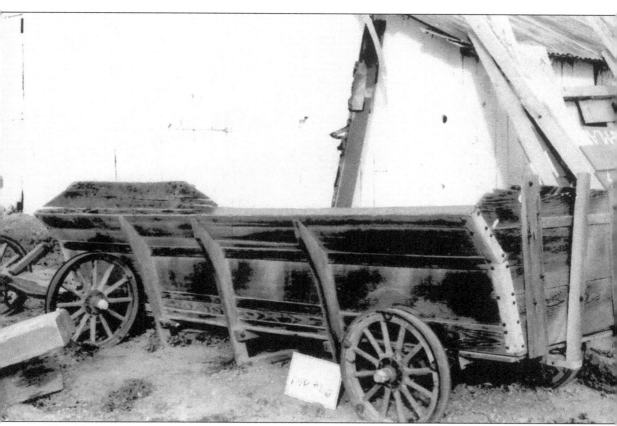

The Aliso Viejo Community Foundation, a nonprofit corporation formed in 1988 by Mission Viejo Company to provide financial support for educational, cultural, and recreational projects in Aliso Viejo, has formed a historical committee to oversee restoration of equipment and artifacts stored on the ranch. This wagon was used to carry farm workers, supplies, and equipment into the surrounding fields and is a candidate for restoration. Old farm implements, tools, and equipment are stored in the ranch barn for future restoration as well as for exhibition during events such as Founder's Day. (Courtesy of the City of Aliso Viejo and the Aliso Viejo Community Foundation.)

A survivor over the years, the Aliso Viejo Ranch shed barn is a testament to the way of life experienced by early settlers, ranchers, and farmers who occupied the land now known as the city of Aliso Viejo. While much has changed around the barn, the structure remains much as it was originally built on the property decades ago. It has served the needs of the Moulton family, the Barnes family, and Mission Viejo Company, and now it serves the residents of the city. The shed barn and grounds of the ranch represent a rare glimpse of a bygone era. (Courtesy of the City of Aliso Viejo and the Aliso Viejo Community Foundation.)

In its three decades of existence, Aliso Viejo has emerged as a thriving, vibrant community that 46,000 people call home. Today, most of the city's land has been developed, and only a handful of parcels remain undeveloped. In a testament to the original master plan and to the stewardship of the city's leaders, Aliso Viejo's six square miles include a balance of residential neighborhoods, parks, recreational facilities, schools, community facilities, and abundant business offices, shops, and stores. It is hard to believe that not so long ago, only a few families and individuals and their horses, cattle, goats, and sheep were the only occupants of this property—the final remnant of the once vast Moulton Ranch. (Courtesy of the Aliso Viejo Community Foundation.)

Visit us at
arcadiapublishing.com

CPSIA information can be obtained
at www.ICGtesting.com
Printed in the USA
LVHW062119271121
704619LV00003B/297